THE NEW
BLACK
WEST

THE NEW
BLACK WEST

PHOTOGRAPHS FROM
AMERICA'S ONLY
TOURING BLACK RODEO

GABRIELA HASBUN
FOREWORD BY JEFF DOUVEL

CHRONICLE BOOKS
San Francisco

For Matteo

Library of Congress Cataloging-in-Publication Data

Names: Hasbun, Gabriela, author.
Title: The new Black West : photographs from America's
 only touring Black rodeo / Gabriela Hasbun.
Description: San Francisco : Chronicle Books, 2022.
Identifiers: LCCN 2021046670 | ISBN 9781797208893
 (hardcover) | ISBN 1797208896 (hardcover)
Subjects: LCSH: African American rodeo performers--
 California--Oakland--Pictorial works. | African American
 cowboys--California--Oakland--Pictorial works. |
 Rodeos--California--Oakland--Pictorial works. |
 LCGFT: Photobooks.
Classification: LCC GV1834.5 .H37 2022 | DDC
 791.8/40896073--dc23
LC record available at https://lccn.loc.gov/2021046670

Manufactured in China.

Design by Allison Weiner and Howsem Huang.

10 9 8 7 6 5 4 3 2 1

Chronicle books and gifts are available at special quantity
discounts to corporations, professional associations, literacy
programs, and other organizations. For details and discount
information, please contact our premiums department at
corporatesales@chroniclebooks.com or at 1-800-759-0190.

Chronicle Books LLC
680 Second Street
San Francisco, California 94107
www.chroniclebooks.com

CONTENTS

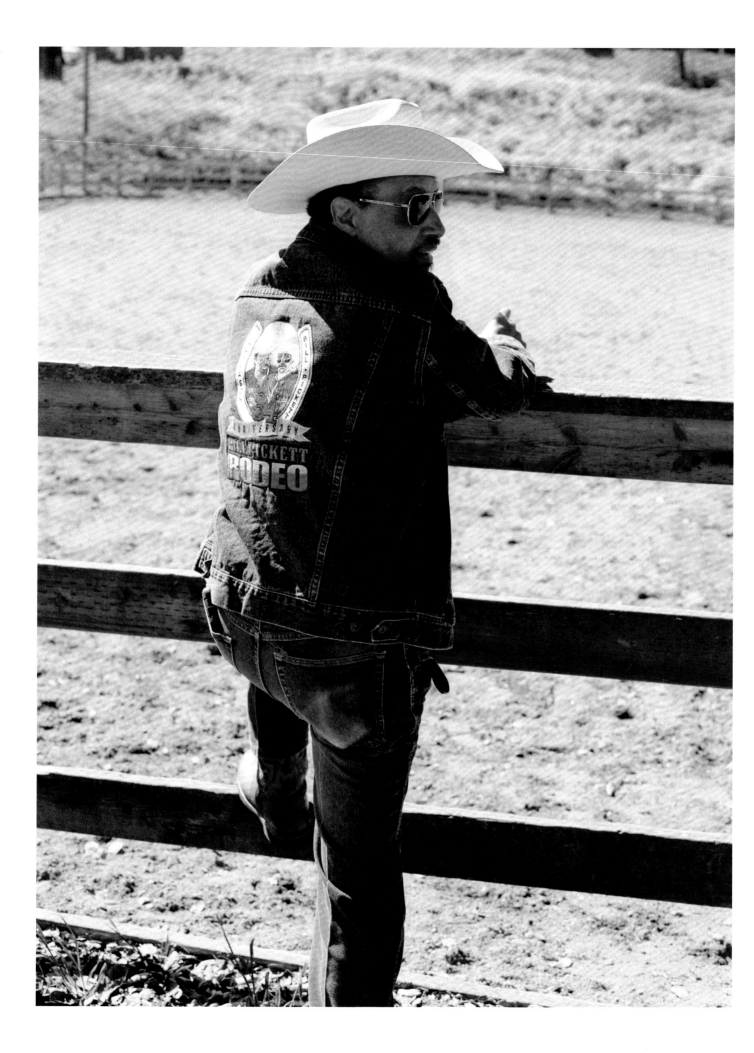

FOREWORD

BY JEFF DOUVEL
REGIONAL COORDINATOR
BILL PICKETT INVITATIONAL RODEO

The Bill Pickett Invitational Rodeo—referred to as "One of the Greatest Shows on Dirt," and the nation's only touring African American rodeo—has seen thirty-six years of chutes, stalls, pens, and staging areas. Gabriela Hasbun's photographs capture scenes that have until now been omitted from visual culture: images of Black cowboys and cowgirls preparing for and participating in the rodeo experience.

From her very first photograph of the rodeo, to her recent images of over four generations of Bill Pickett Invitational Rodeo cowboys and cowgirls, Hasbun captures details that tell a story of the pride felt by the person in the shot, many of whom didn't even know they were being photographed.

ARTIST'S STATEMENT

PHOTOGRAPHING THE BLACK COWBOYS, 2008–2021

It's hard to imagine a more powerful symbol of self-reliance, strength, and determination than the cowboy. While the archetypal cowboy is a highly romanticized figure, and one that ignores ugly truths about the cost of westward expansion in the United States—namely the theft of Native American lives and land—still it has become synonymous with traits we almost universally admire. And while the archetypal cowboy is almost always depicted as white, in reality no one better embodies these admirable traits than the Black cowboys who helped shape the culture of the American West. According to the late historian William Loren Katz, whose book *The Black West* tackles the whitewashed mythology of the American frontier, people of African descent "rode every wilderness trail—as scouts and pathfinders, slave runaways and fur trappers, missionaries and soldiers, schoolmarms and entrepreneurs, lawmen and members of Native American nations." Although their stories have largely been untold, more than eight thousand Black cowboys rode in the western cattle drives of the late 1860s. It's my privilege to introduce you to the men and women who carry on their legacy today.

I have been documenting Black cowboys in the San Francisco Bay Area at the annual Bill Pickett Invitational Rodeo since 2008. The families who return to the rodeo each year come to support one another and the other contestants. It's a testament to their commitment not only to the sport, but to their community. The bonds that are forged at the rodeo are undeniably strong. As cowboy Jamir Graham said to me recently, "My rodeo team is my family."

It was the intimate moments behind the scenes, the quiet time the riders share with their horses before a competition, and the relaxed atmosphere when the rodeo has ended that lured me to document the contestants and the attendees many years ago. The beauty of the bonds they've formed—with the horses and with the other riders—continues to astound me. The intimacy, trust, and understanding are palpable both on and off camera.

The rodeo itself is named after a famous Black cowboy. The legendary Bill Pickett was the first Black rodeo athlete to be honored in the Rodeo Hall of Fame in Oklahoma City; he was inducted in 1971. The Miller Brothers recognized his talent in 1905 and hired Pickett to travel with them as a performer and exhibitionist in their 101 Ranch Wild West Show. Pickett was famous for grabbing a steer's lip with his teeth—a feat known as *bulldogging*, as that is what bulldogs would do while herding steers—and became well known for being a fearless and skilled rider. At the time, Pickett did not participate in the rodeos, as Black cowboys were not allowed to take part in the main rodeo and had to compete after the crowds had left. But at the Wild West Show, people from all over would come to admire his bulldogging and bull-steering skills as part of the show. The audience didn't seem to care that Pickett was Black. They were enthralled by his talents.

The Bill Pickett Invitational Rodeo (BPIR) was founded in 1984 by Lu Vason, and to this day it remains the nation's only touring Black rodeo. A hairstylist, concert producer, and promoter, Vason became interested in rodeos while attending the granddaddy of them all: the Cheyenne Frontier Days rodeo in Wyoming. He quickly realized that there were no Black cowboys participating in that legendary production. On his return to Denver, where he resided in the 1980s, he began his research at the Black American West Museum, exploring the history of Black cowboys, the contributions of African American settlers, and the opening of the western frontier. After more than two years of research and fundraising, Vason produced the inaugural Bill Pickett Invitational Rodeo in Denver, Colorado. This heritage rodeo helps educate people from all over the world about the rich history of Black cowboys and cowgirls, and it highlights their overlooked contributions to American rodeo culture.

The modern rodeo I've witnessed annually at Rowell Ranch Rodeo Park, just outside of Oakland, California, is a study in generational shifts. As young contestants enter this traditional competition, they bring with them new perspectives and styles. Gucci sunglasses and Stetson hats, cell phones and lassos, Louis Vuitton saddles

and Wrangler jeans—it's clear that something completely new is being forged in the collision of classic and contemporary. And not only are the riders inventing a new aesthetic, but they are exploring what it means to be a cowboy in contemporary America, in and out of the arena. Many cowboys and cowgirls believe the sport has saved their lives, and all of them recognize the intense discipline needed to keep and care for their horses. That discipline requires passion and commitment in equal measure. Oakland native Brianna Noble explained, "I am really just so grateful that I could have such a positive addiction, because I really think that horses are actually, truly a drug and addiction in the most positive sense of it, you know. They really have kept me on the straight and narrow throughout my life and taught me an unmatched work ethic, and really just kept me into all the positive things in my life."

The people who gather annually for the rodeo make up one of the most lively, bighearted, kind, and compassionate communities in the Bay Area. Many cowboys and cowgirls also run year-round youth programs—Brianna Noble's Mulatto Meadows, Sam Styles's Horses with Styles, and the Spurred Up program, for example—that offer inner-city kids the opportunity to work with horses as a form of therapy. "I'm always looking for the next thing to help these kids. I'm looking for the next way to get another kid here," said Styles of his youth program. "Riding is not for everybody. And I know I can't save every single life. But if I could get one more kid here and keep them off the streets of Oakland, or be able to get them away from what they're going through at home, in a troubled situation—I mean that's just one more kid who could have a different outlook on life."

For decades, these urban cowboys have found joy in the traditions passed down by their predecessors. I have gotten to know many of those who participate in the rodeo, most of whom have a strong network of friendships in the Bay Area. Throughout my twelve years of attending the rodeo, my friendship with the cowboys has brought me closer to their communities and families. They have invited me to their ranches to see them ride and care for their horses outside the arena. I've taken hundreds of pictures over the past decade that document the talent, dedication, and love of this community. It's a dream come true to share their passion and skill with the rest of the world.

I hope my images inspire you to follow your own passion and joy, as the cowboys have inspired me.

GABRIELA HASBUN

Note on the image captions:
Unless the caption states otherwise, all photographs were taken at the Bill Pickett Invitational Rodeo at Rowell Ranch Rodeo Park outside of Oakland, California.

Rodeo attendee Deidre Webb, known as Lady D, visits the Bill Pickett Invitational Rodeo (BPIR) in Oakland from Washington State in 2019. A few years before, she visited a close friend in Oakland who invited her to the rodeo, and since then she's become a loyal fan. A survey taken at the 2018 event revealed that 56 percent of attendees were new to the rodeo, and about 45 percent were introduced to the rodeo through friends or by word of mouth. "At the BPIR we found family," Lady D says. "My first day there, Pam let me ride her horse, and she had one of the other cowgirls walk me around that whole big back area on the horse. So yes, we found family, for real."

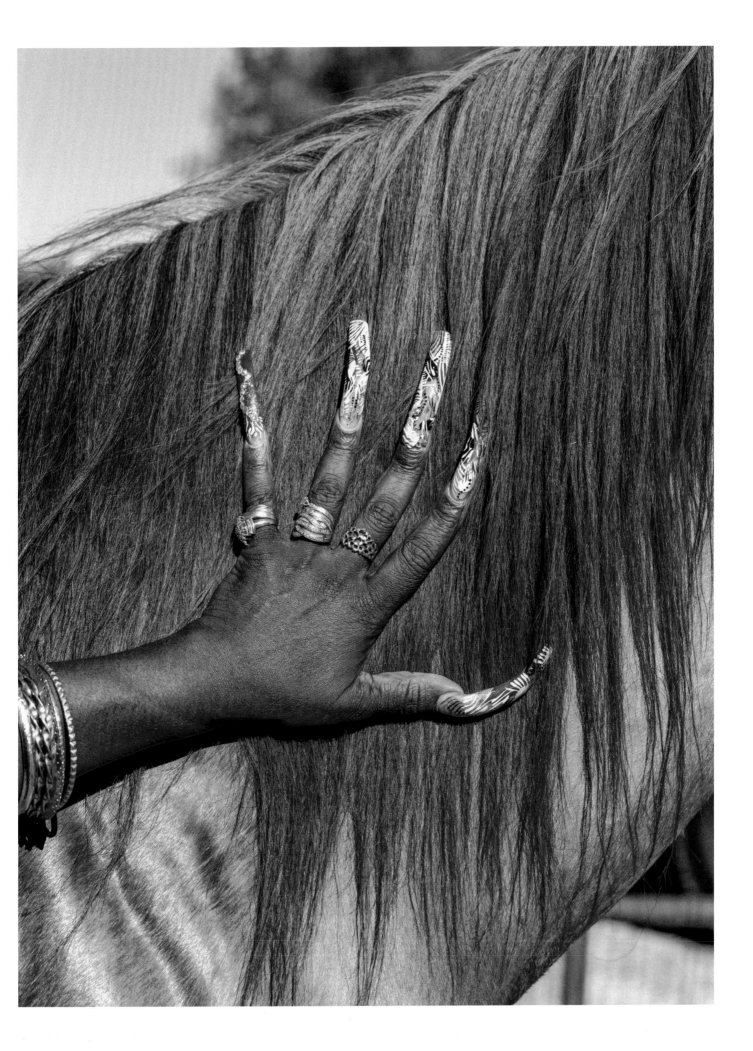

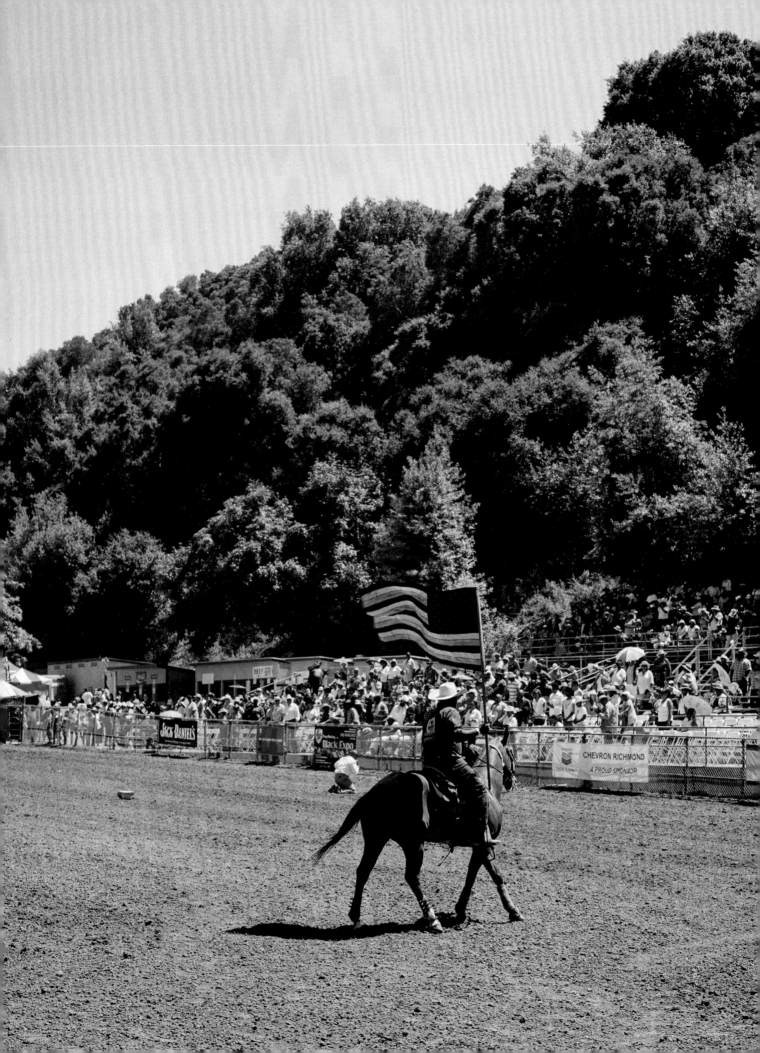

A cowboy at the 2017 BPIR waves a version of the African American flag as he rides around the arena introducing the show. According to bull rider Trevor Clark, "The BPIR is considered a heritage rodeo because we honor and display the history of the Black cowboys. For me, participating in the BPIR is bittersweet. You get to see everybody, and you're like, Wow, I'm not the only one. And there's all these other people who look just like you that are, you know, just as talented if not more. They get to compete with you, and you know, it's always cool when you get to see somebody like you doing the same thing when everywhere else is not like that. . . . There's plenty of other people who ride horses [who] are the same color as you."

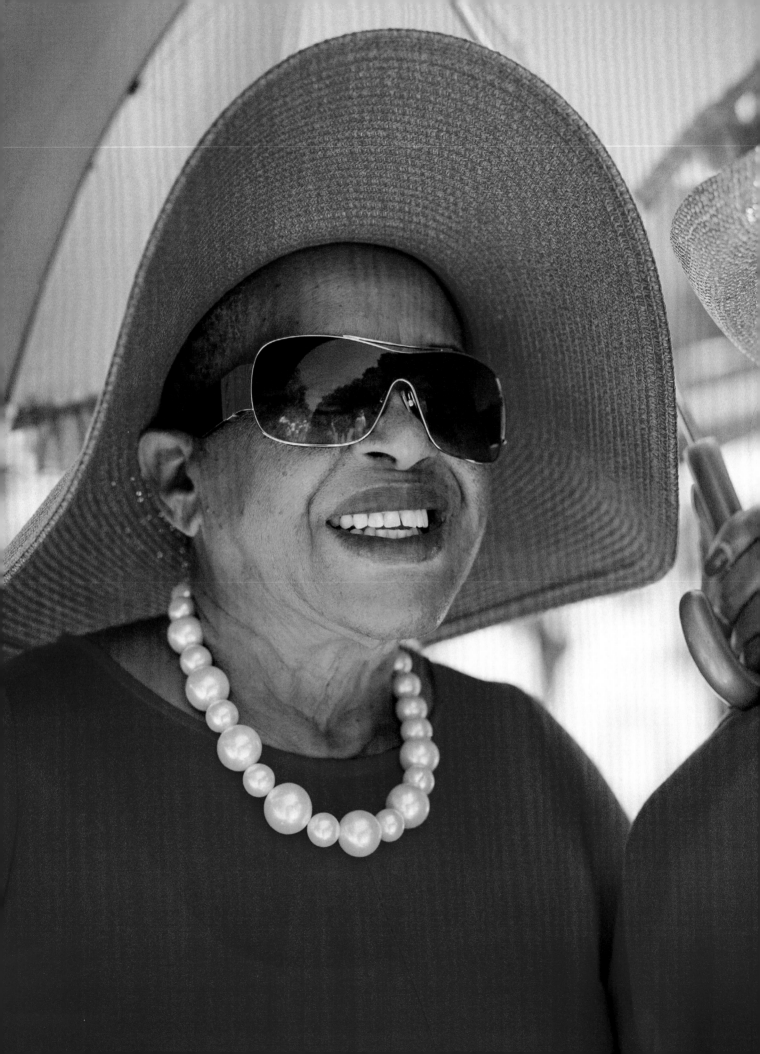

A spectator at the 2017 Bill Pickett Invitational Rodeo in Oakland wears her Sunday best attire.

"The outfit that I have on is what I wore when carrying the African American flag in the very beginning of the rodeo," Denesha Henderson explains about this image from 2008. "It's tradition to wear the chaps and the decorative shirt. That's how we pay tribute to both the American flag and African American flag." Denesha has been competing at the BPIR for more than twenty-four years. "The rodeo and horses are definitely the one thing that has always remained constant in my life," she says.

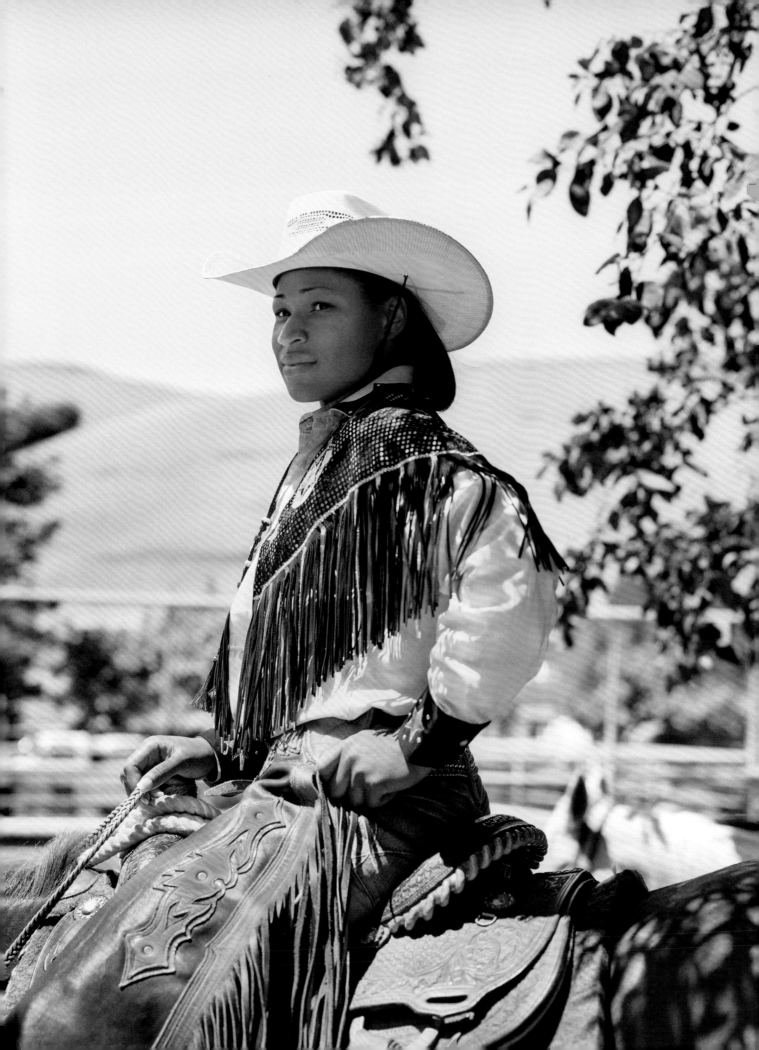

A cowboy warms up his horse before competing in the
2008 BPIR at Rowell Ranch Rodeo Park.

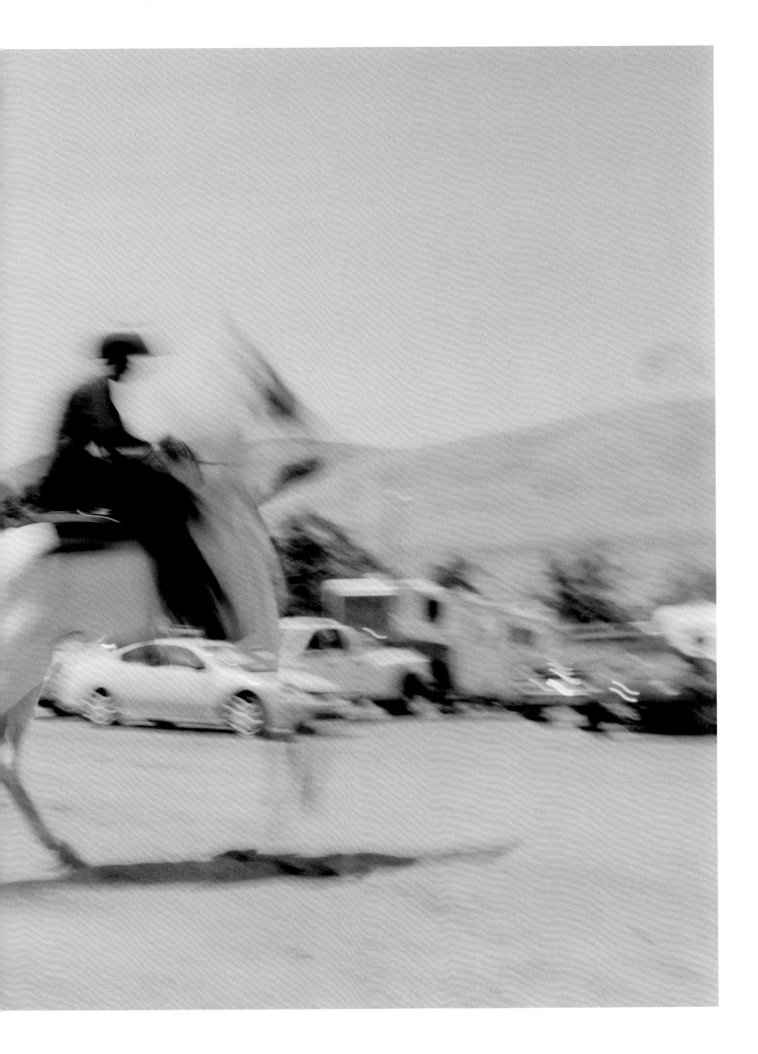

It's tradition to spend some moments in prayer at the beginning of the BPIR. In this image from 2017, participants and spectators ask God for the safety and well-being of all the cowboys and cowgirls, and they sing the Black national anthem, "Lift Every Voice and Sing," by James Weldon Johnson.

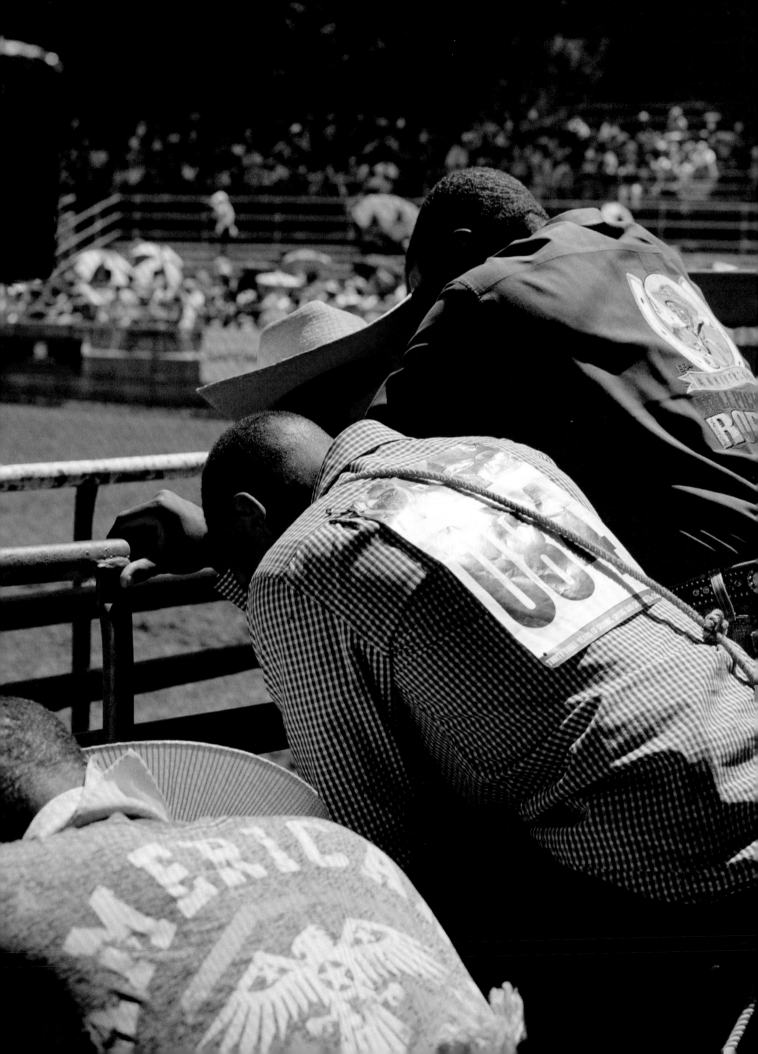

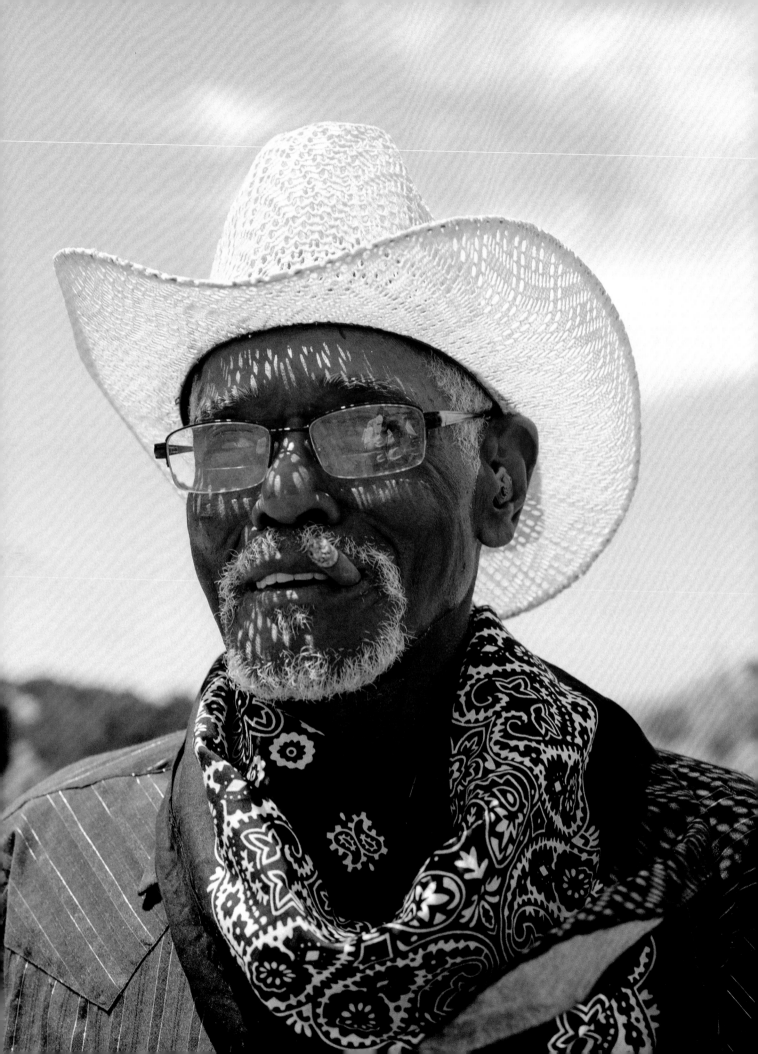

Robert "Cowboy" Armstead, here in 2018, a retired racehorse groomer from Stockton, California, is eager to keep Black cowboy history alive in the West. He was the groomer for Foolish Pleasure at the Kentucky Derby in 1975. "Working the racetracks was the life," he says. "Traveling town to town, city to city, making all this money. Working the tracks was really good. I love horses. I would do anything in the world to be around them all the time."

"This is my parade saddle," says cowboy Pat Davis. "I wanted to stand out." Pat had a custom Louis Vuitton saddle made for his Belgian draft horse, Hercules, to wear during the BPIR Grand Entry in 2009.

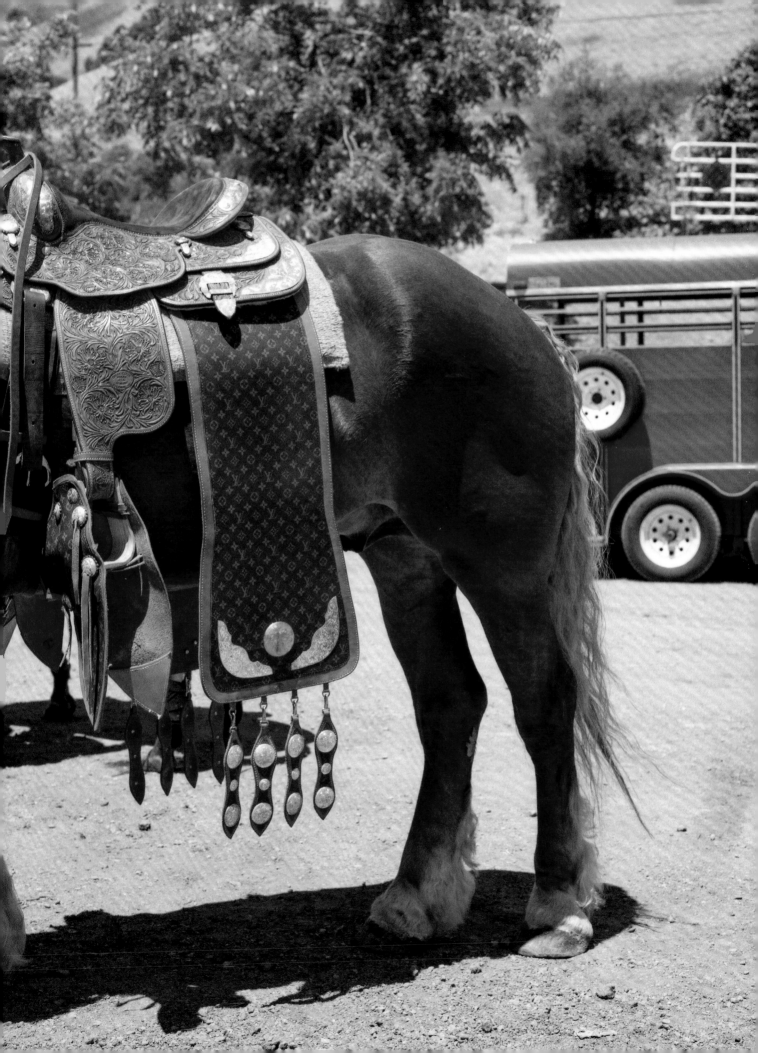

Cowgirl Brianna Owens traveled from Houston, Texas, to compete in the ladies'
barrel racing at the BPIR in 2017. Barrel racing is one of the two events open to
cowgirls only. The other is ladies' steer undecorating.

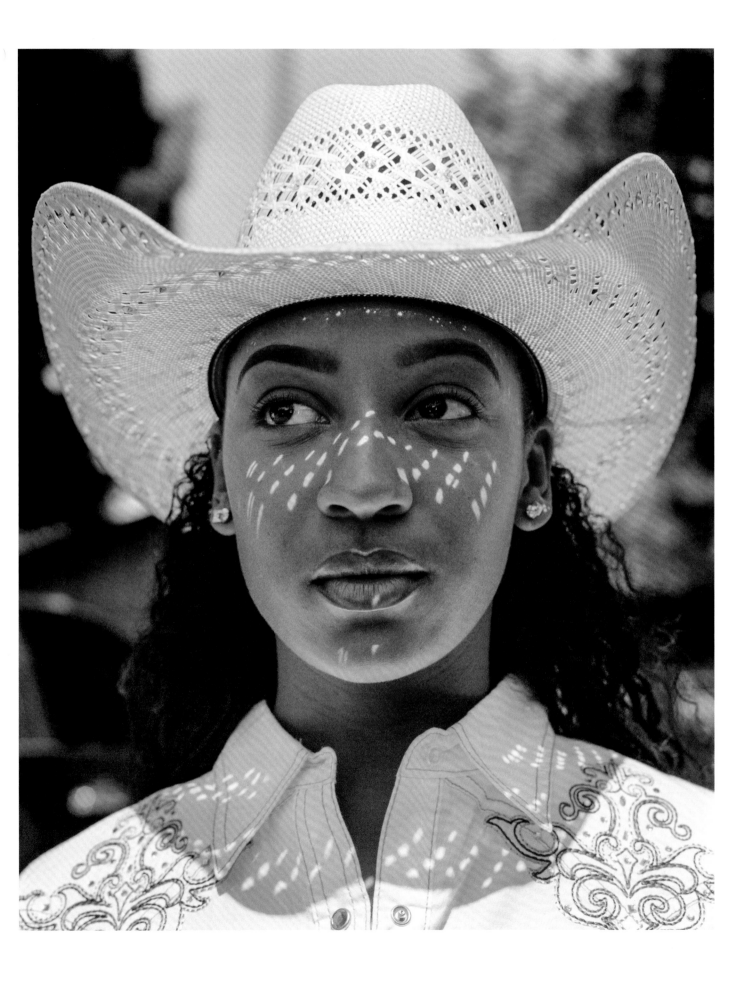

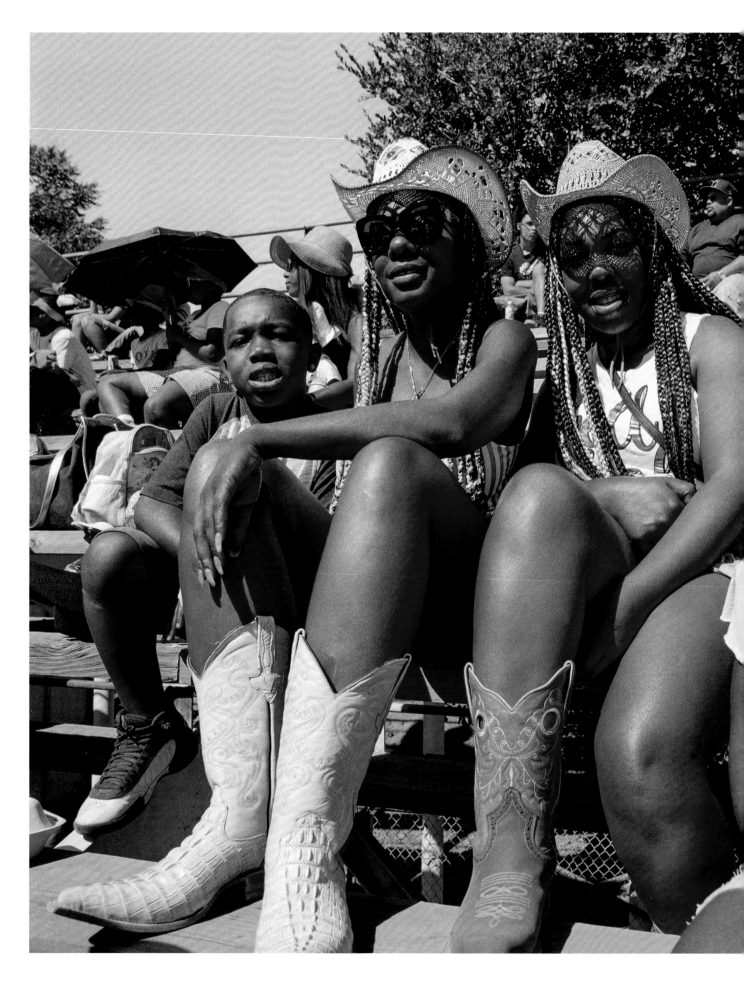

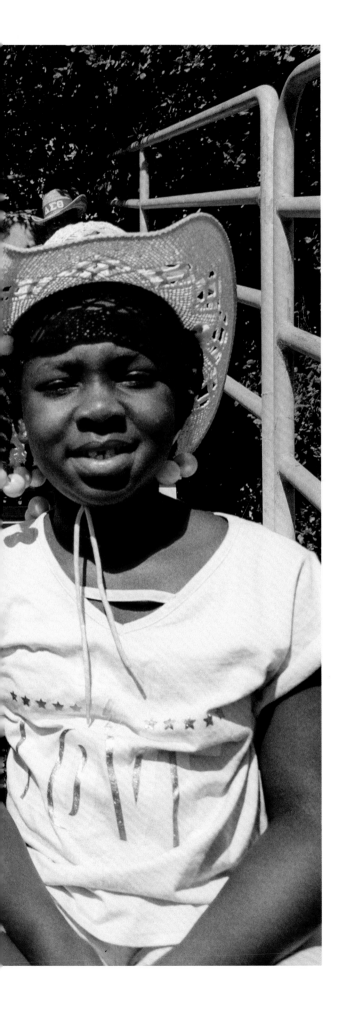

At this heritage rodeo, families in Oakland come to honor the Black cowboys who helped settle the West. More than eight thousand Black cowboys rode in the western cattle drives of the late nineteenth century. This image is from 2018.

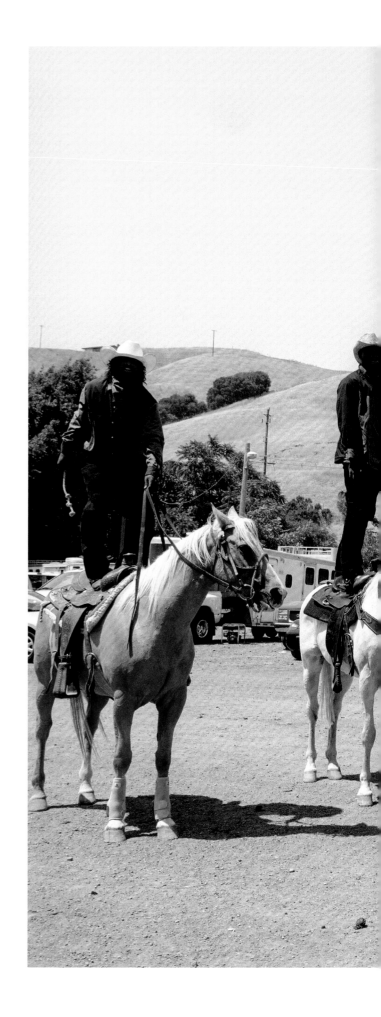

Joseph "Dugga" Matthews (far right) stands on his horse in 2008 with a group of riders from Stockton, California, who are part of the Brotherhood Riders group. Dugga is a horse trainer, farrier, and veterinarian. He came to the States from Antigua in 1998, and has been attending the BPIR ever since.

next spread, left: Contestant Trevor Clark explains what it's like to ride bulls at the 2017 BPIR: "I'm an athlete. I played a lot of sports in high school, and then I went on to play college football. It's literally the same type of atmosphere at the rodeo, same adrenaline, the same odds against you. It's all the same. The adrenaline rush of bull riding is like a drug—just the thought that you could ultimately lose your life with the slightest mistake."

next spread, right: A veteran bull rider, Leroy Patterson Jr. travels nationally to train young bull riders. He is well known for wearing his snakeskin cowboy boots, pictured here in 2017. "I had these boots handmade in Tijuana," he says. "Five hundred bucks. That was cheap."

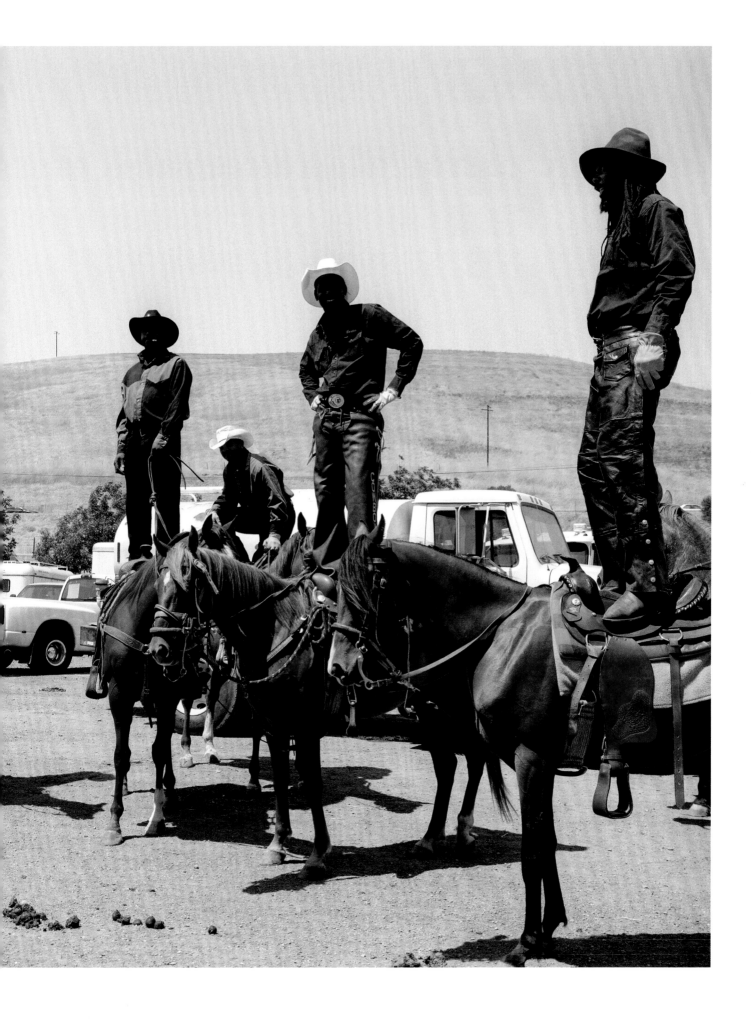

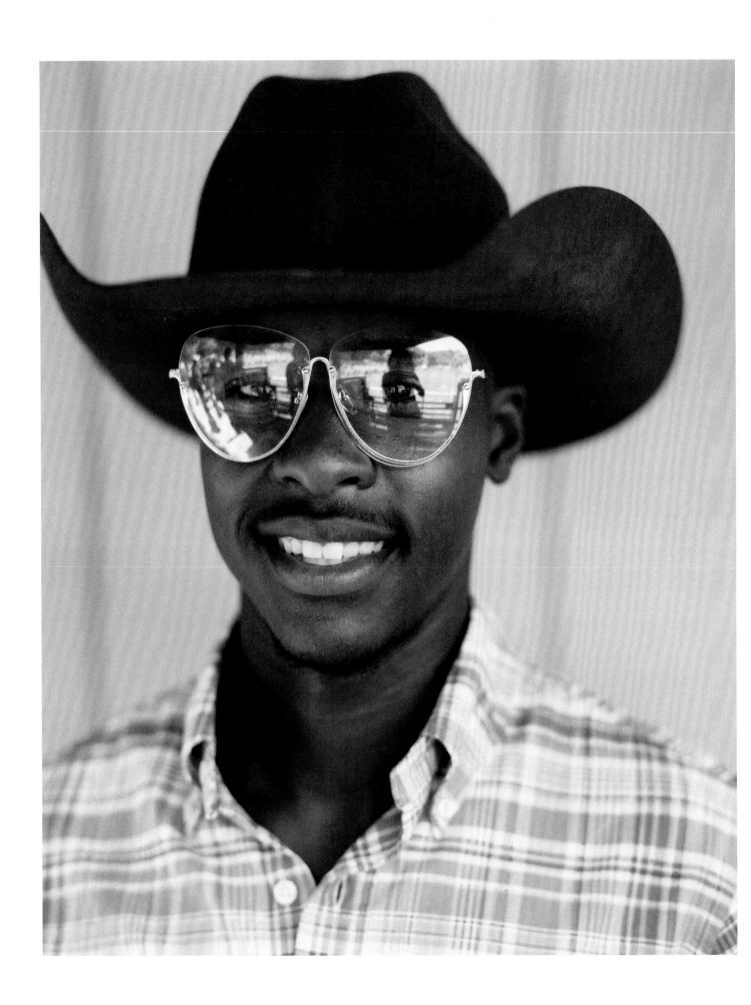

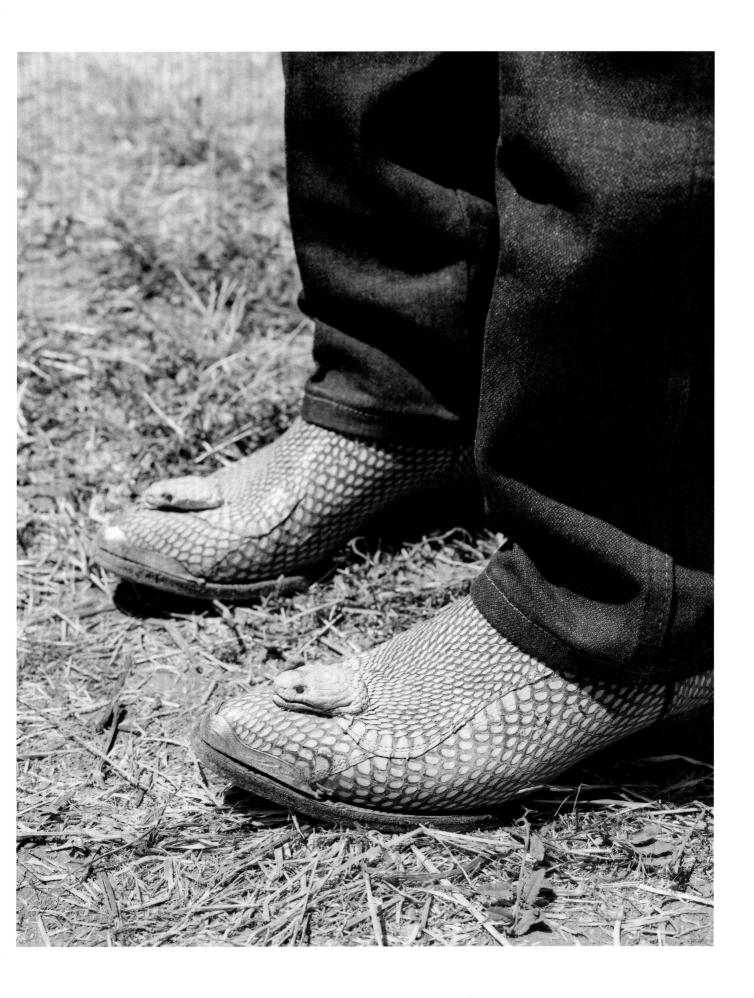

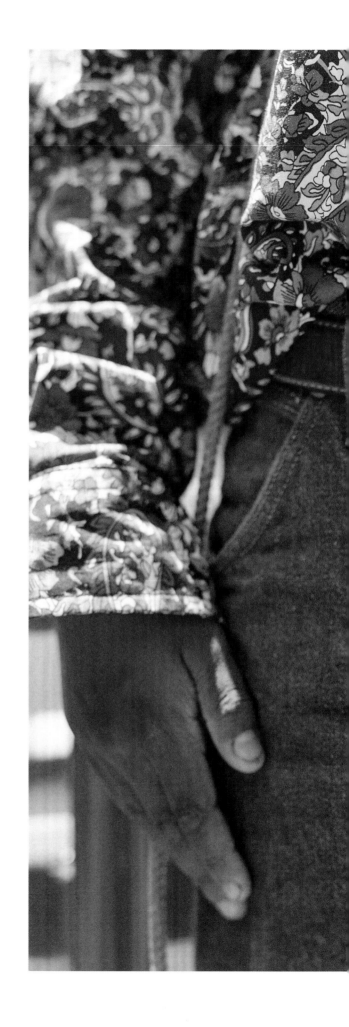

Ron Hill Jr., photographed here in 2018, competes regularly in steer riding at the BPIR. At age seven, he was the calf-riding champion at the Pacific Coast Junior Bull Riders. His father, Ron Hill Sr., explains: "I met my wife at the BPIR in the City of Industry back in 2009. We hit it off and created a young cowboy of our own. Ron Hill Jr. started off as an infant riding in my arms around our property. By the age of three, he was competing in rodeos riding sheep. By the age of five, he started riding calves and steers."

next spread, left: Rodeo attire is all about the details. This image from 2017 shows off the spurs on the boots, the perfectly curved hats, and the pressed cotton shirts with embroidered stars. "At the rodeo, you want to be dressed to impress," says Trevor Clark.

next spread, right: In 2019, bull rider Rick Reddick proposed to his girlfriend, Oriana Miller, center stage at the Bill Pickett Invitational Rodeo. "They made it sound like she won some kind of contest," he explains. "And instead of winning a contest, I proposed. The Bill Pickett was the perfect place to do it because, you know, it's somewhere that we both have ties to. Both of our roots go back to the Bill Pickett." This photo was taken at the rodeo two years prior, in 2017.

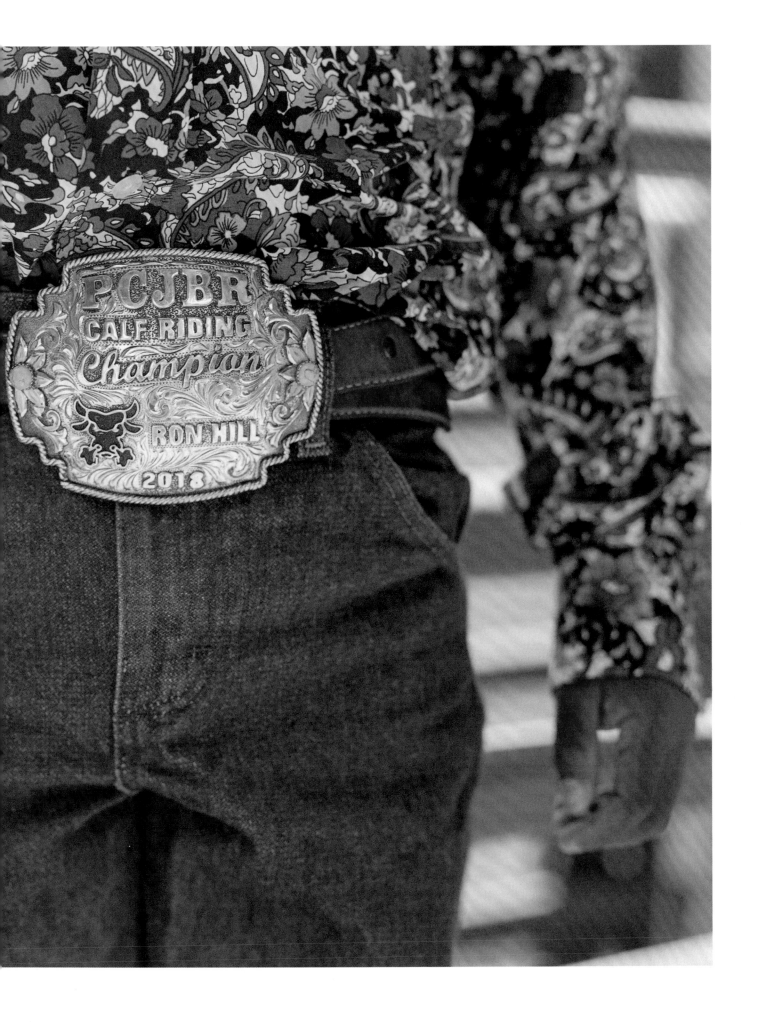

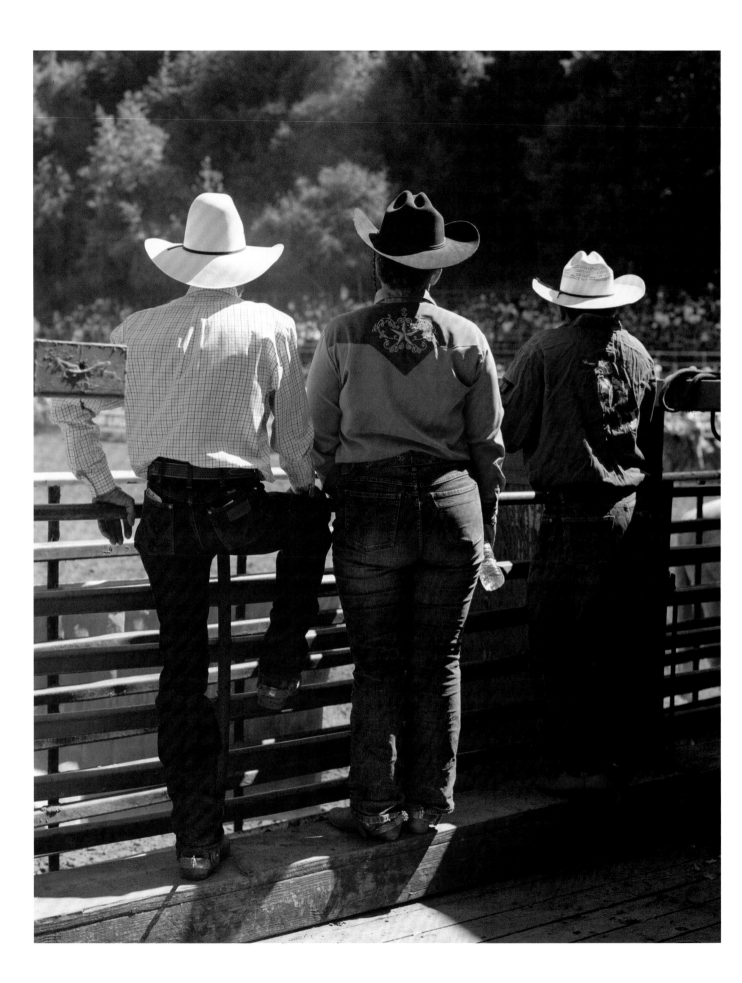

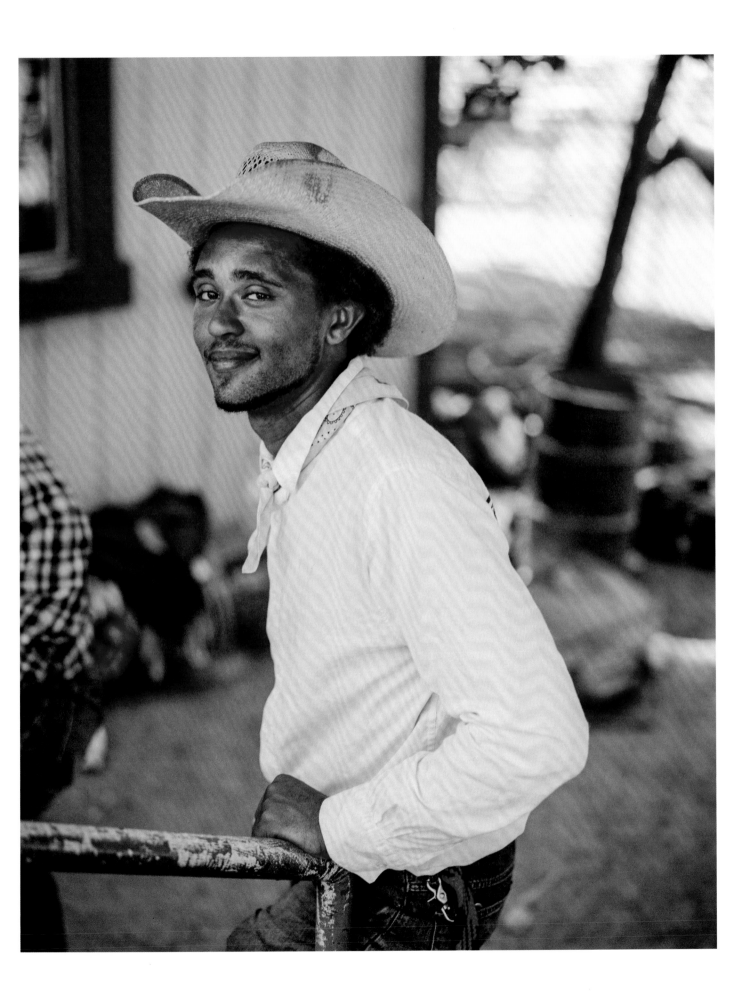

Barrel racer Kysariah Brinson shows off her custom hat, which features a drawing of her horse, Chad, in 2019. Kysariah has been riding since she was nine years old. She loves riding more than anything and competes nationally in the rodeo circuit. "My mom actually drew Chad out and took the hat to a tattoo shop in downtown Oakland to get it airbrushed," she explains. "I don't like to dress boring. A lot of people like to wear the basic colors like brown or blue. I like to bling and shine. I'm a very flashy person when it comes to rodeo. With rodeo, more of the girly side comes out."

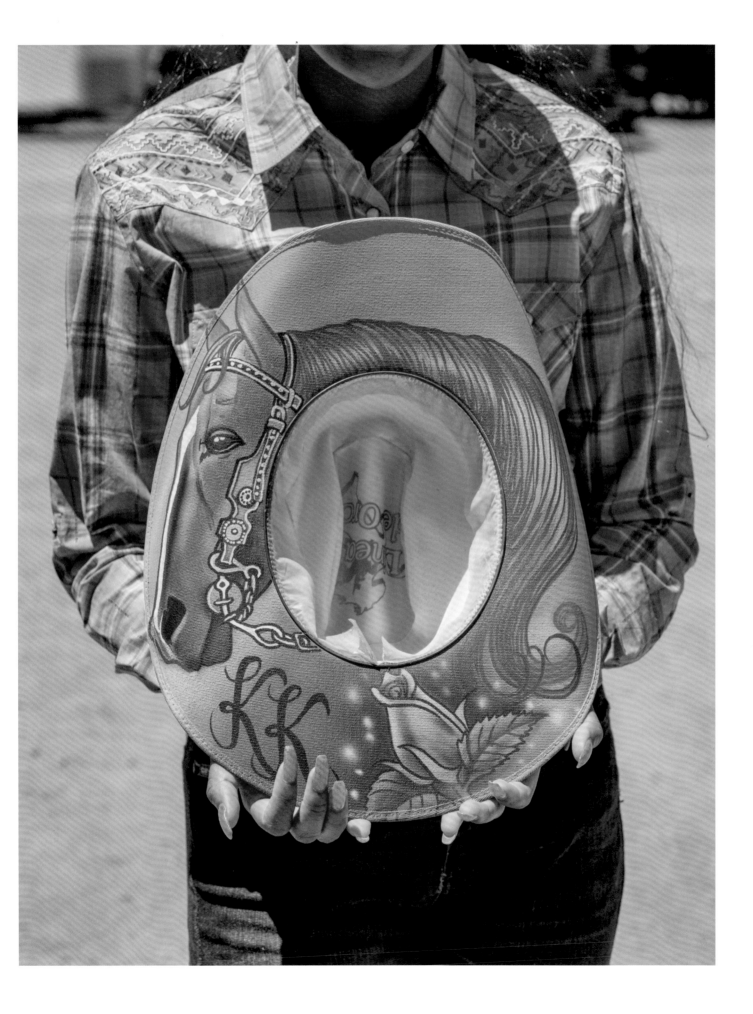

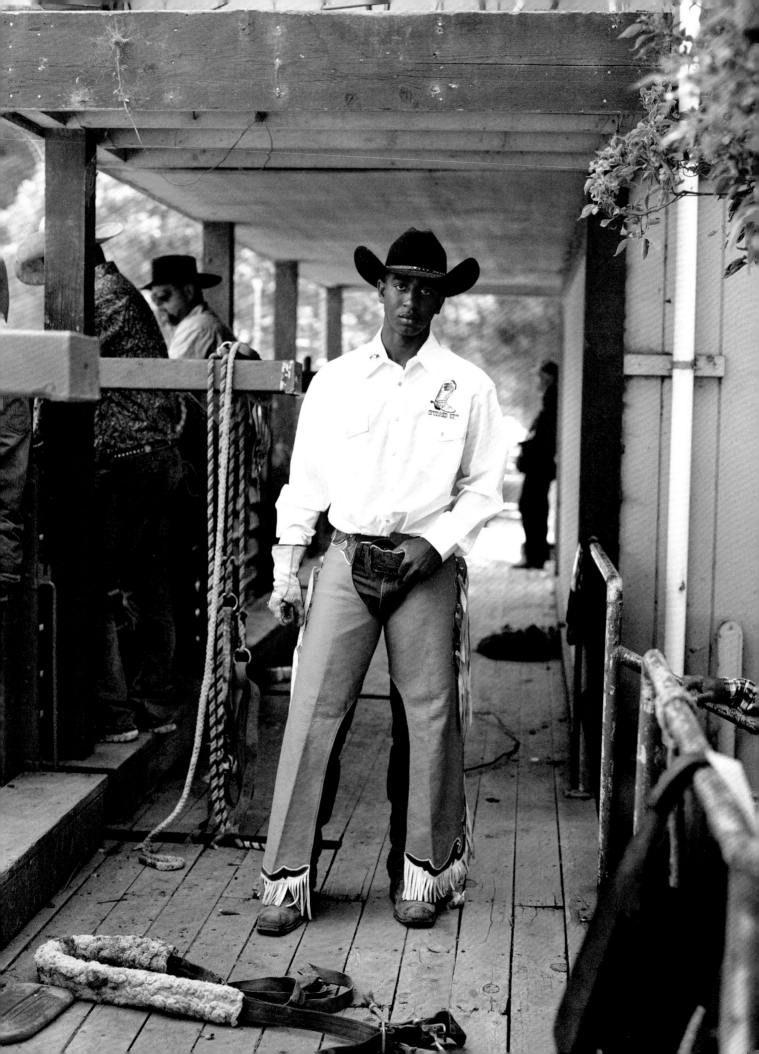

Cowboy Jamir Graham nervously awaits his turn to compete at the thirty-second annual Bill Pickett rodeo in 2017. This was Jamir's first racing competition at the BPIR. He was sponsored by his youth program, Spurred Up. "I participated in bareback riding and relay racing. I was also the flag bearer with the Spurred Up flag for the Grand Entry," he remembers. "I was born into riding. Growing up, my mom and grandfather competed. So for me, BPIR has always been a big family reunion."

Calf-roping contestant Keary Hines traveled from Texas to compete in the BPIR in Oakland in 2017. "That was my first personalized rope can that was custom made for me by a leather maker out of Georgia," he says. "It was kind of an arrival gift to myself. All the pros have them. I use the same ropes as the pros. They're called grass ropes, and they're literally made from grass. So they absorb moisture, and they get stiff, and when exposed to heat that'll make them limber like a shoestring. . . . I don't want to change the body of my rope, so I have to make sure I protect it. . . . That's why the can's round and hard like it is."

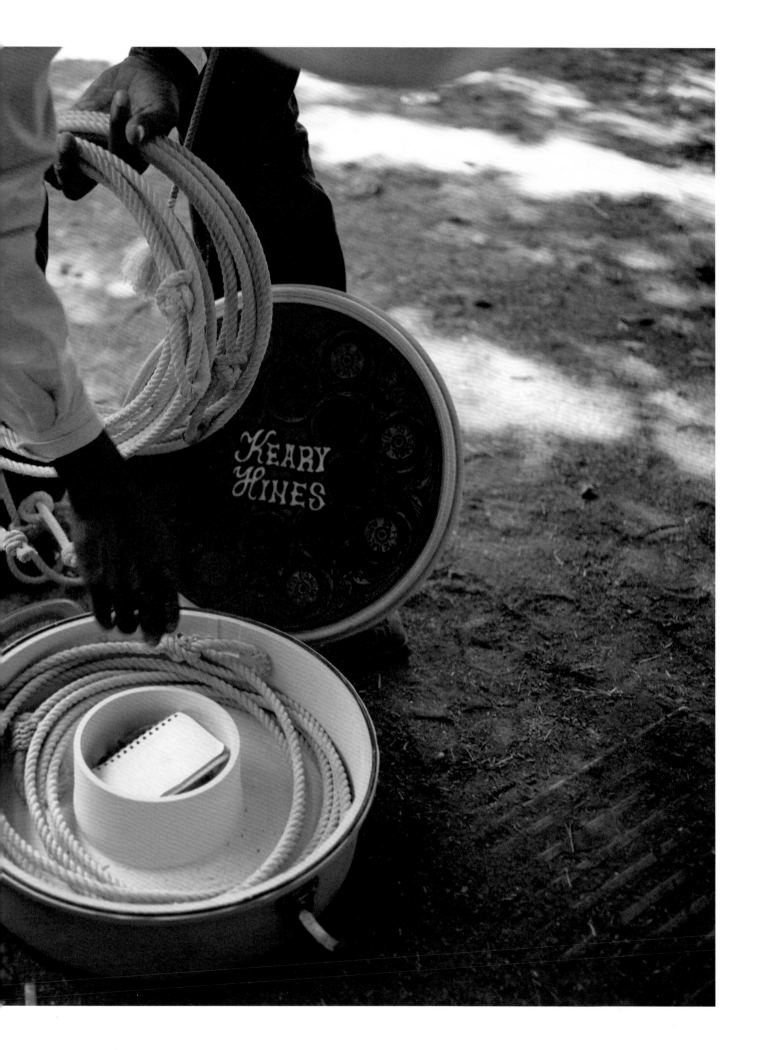

Barrel racing contestant Little Jackie "Speed" Garner and son Jo'siah Nelson spend time together moments after the Grand Entry at the 2008 BPIR in Oakland. "Having horses is the most rewarding thing," Little Jackie says. "At the end of the day I know I have someone who loves me like no one else. Me and my horse, Blue Dream, we have our own bond. No words needed. He speaks my language. I can't explain it. It's the best feeling."

next spread: Ladies' steer undecorating contestant Denise Johnson, from Houston, Texas, observes the action in the arena in 2018 and reflects on her life: "I come from a rodeo family. My dad rodeoed. I started riding at a very early age. I was nearly born on a horse. I started off barrel racing. Then I had a chance to compete in all-girls rodeo. I met my husband at the rodeo. Rodeo is the foundation to our family. It truly takes a village to raise kids. I'd rather have my kids play in the dirt than play in the streets. Rodeo is what keeps my kids grounded and keeps me active."

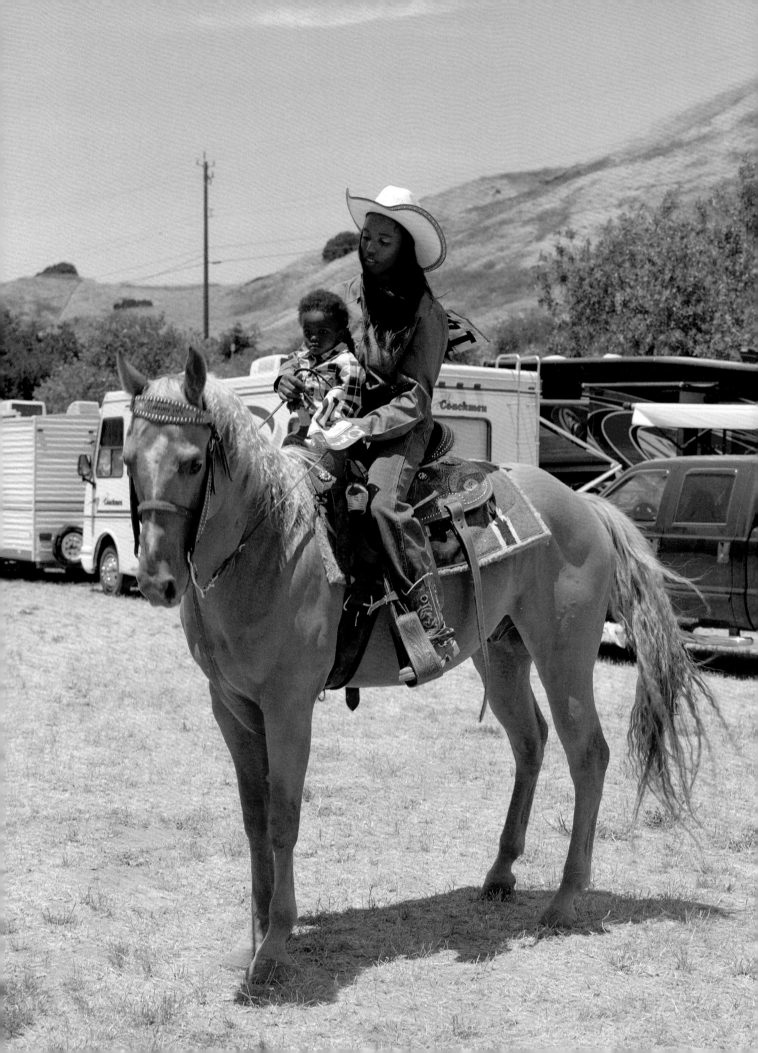

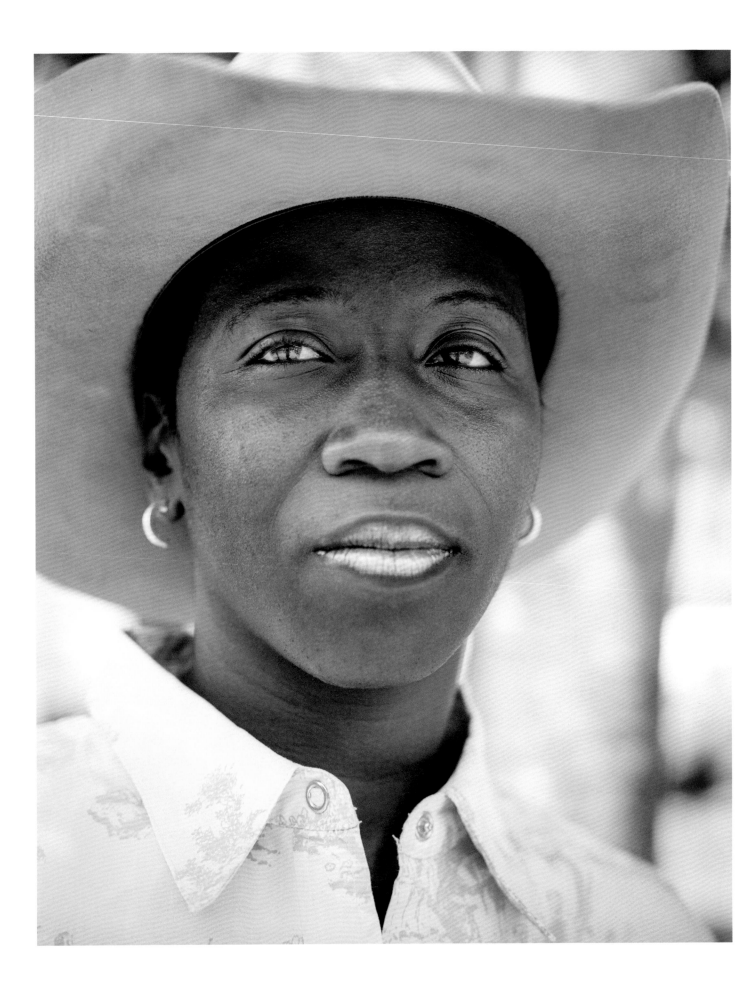

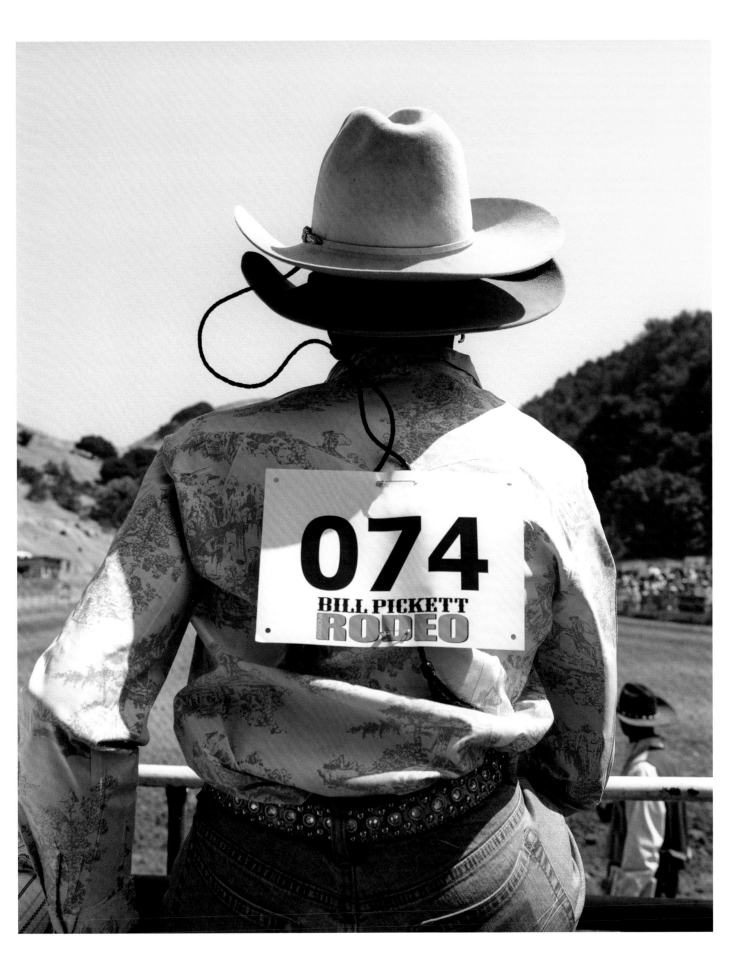

Mother and daughter cowgirls from Atlanta, Adrian Vance and Ronnie Franks (in red), sit behind the scenes, where contestants watch the spectacle in the arena. "Black rodeo is a celebration of African American history and culture. We ride on behalf of those who did not have the opportunity to do so," says Ronnie, thirteen years after this photo was taken in 2008. "Lu [Vason, BPIR founder] would have been proud to see this book published."

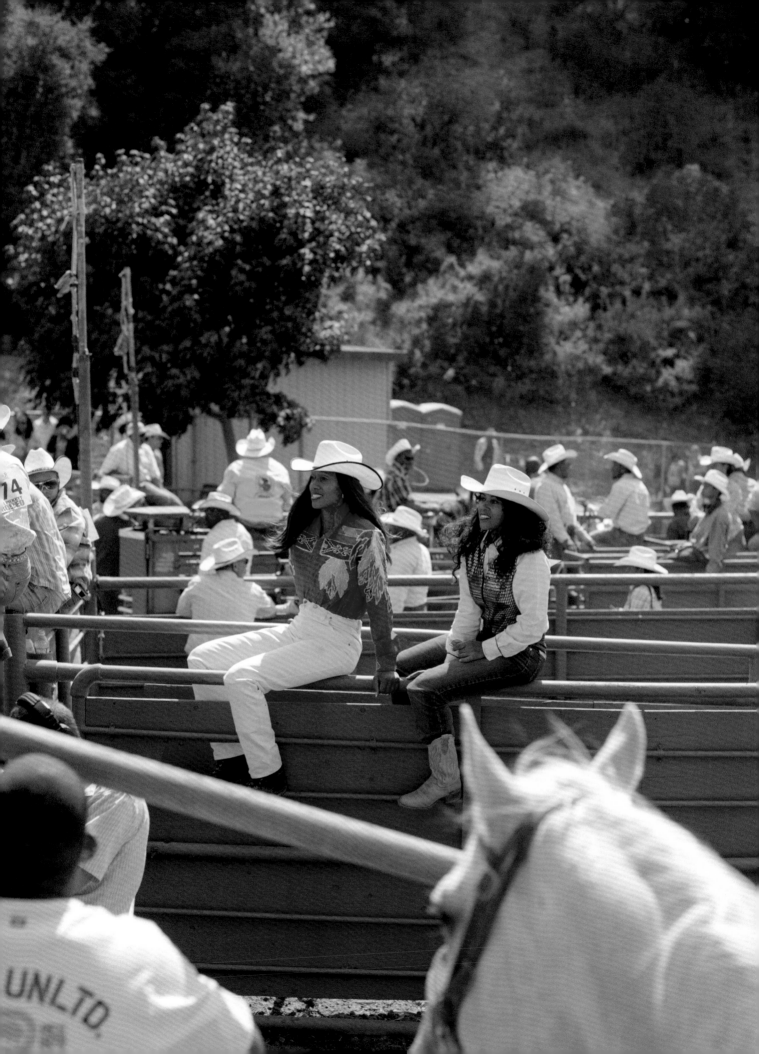

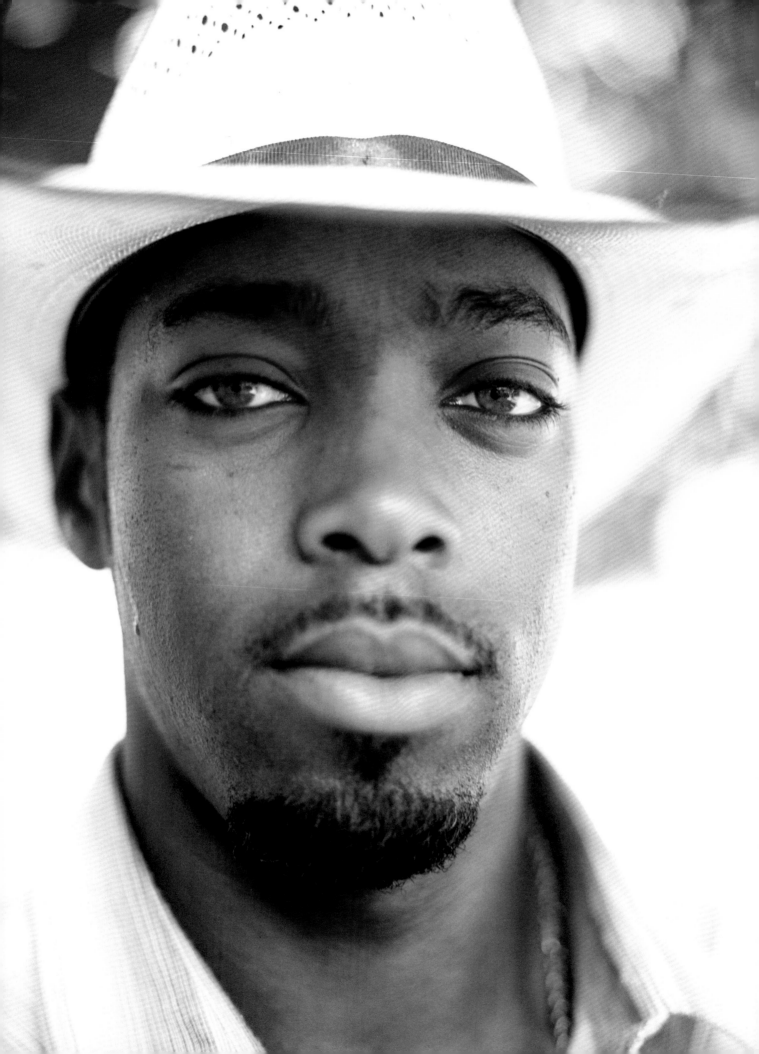

Bareback rider and rodeo contestant Ashanti Samuels participated in the 2008 BPIR in Oakland. "The first time I saw horses was around the age of four to five," he says. "This man, Larry Randall, brought horses to my elementary school in Atlanta. After that I was hooked. In middle school I started skipping school and riding wild horses in the woods behind my school." Later on, a dream came true for Ashanti when world champion bareback rider Bobby Mote agreed to train him in Oregon. Ashanti moved west from the projects of Atlanta. He now owns and operates a farm in Oregon called Rain Shadow Organics and credits his success to the discipline learned during his rodeo days.

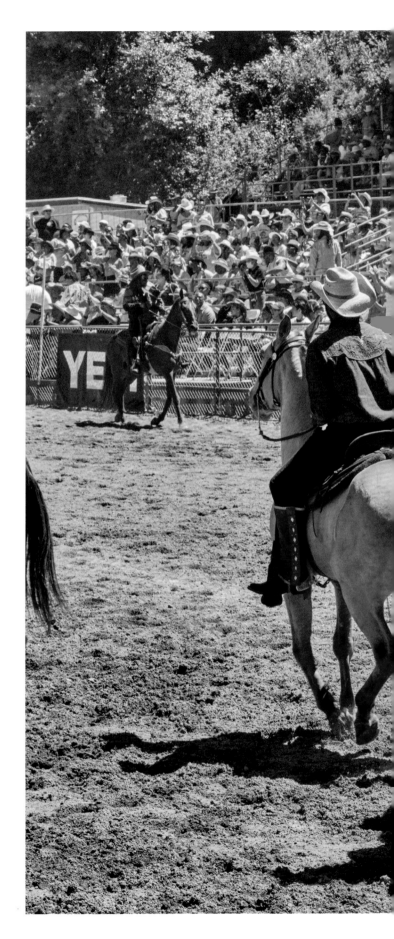

Prince Damons, Cowboy Sam, and Cowboy Jonathan Higgenbotham parade their horses at the Grand Entry of the BPIR in 2019. This is the most anticipated event at the rodeo, where guests are able to observe and celebrate the entire cowboy community, regardless of their participation in the competitive events. Riders glam up themselves and their horses to look their best.

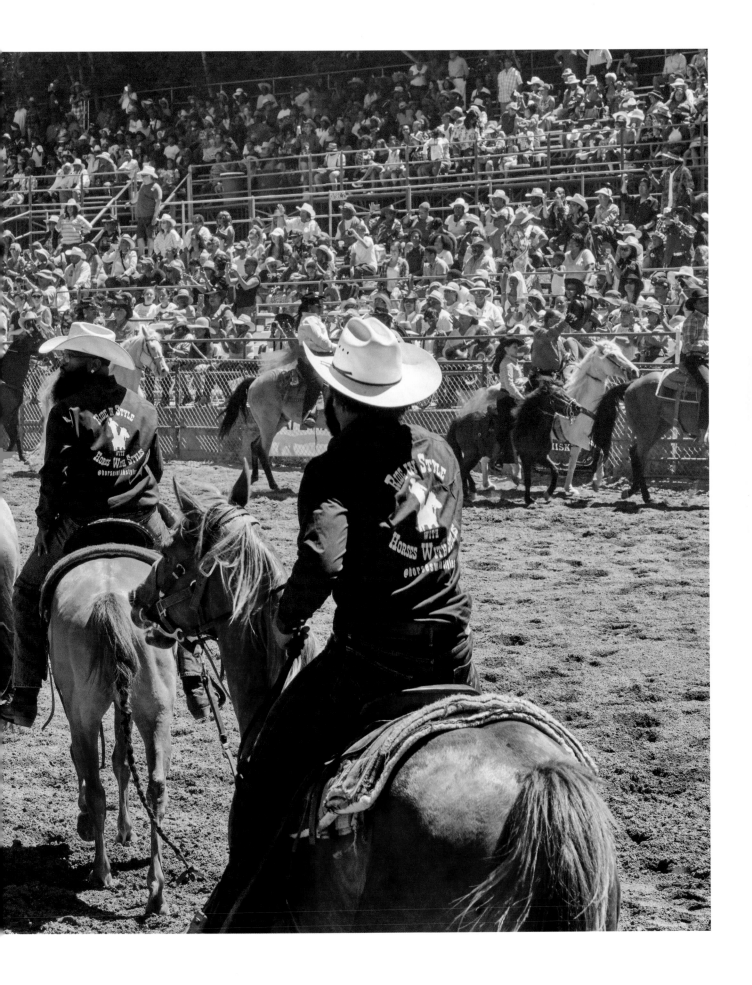

A spectator arrives early to save seats at the 2018 BPIR before the large crowds arrive. "What really struck me about the BPIR," says Ifafunke Oladigbolu, "was how close-knit the community was of Black cowboys, and how there were other tight-knit communities like Black firefighters and Black police officers and Black gospel groups. So it was really cool seeing these communities that are right here in Oakland that you're not really aware of until you go to something like that. They all came out in groups to show their support for the cowboys. And then realizing it's not just in Oakland—it's nationwide—just blew my mind."

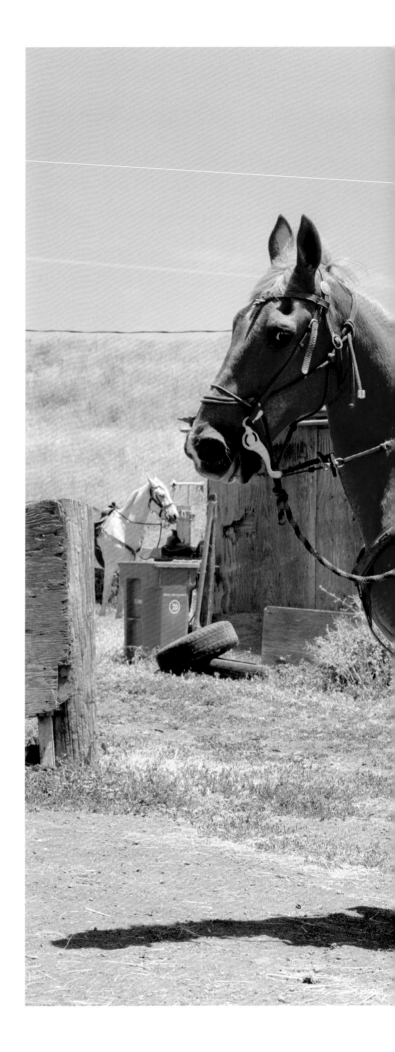

Iyauna Austin rides her horse Diamond at No Name Ranch in Fremont in 2018. "One important thing about horses," explains Iyauna, "is that when people ride horses, it boosts your confidence and encourages you to do things you never thought you would do. Horses are incredible confidence boosters."

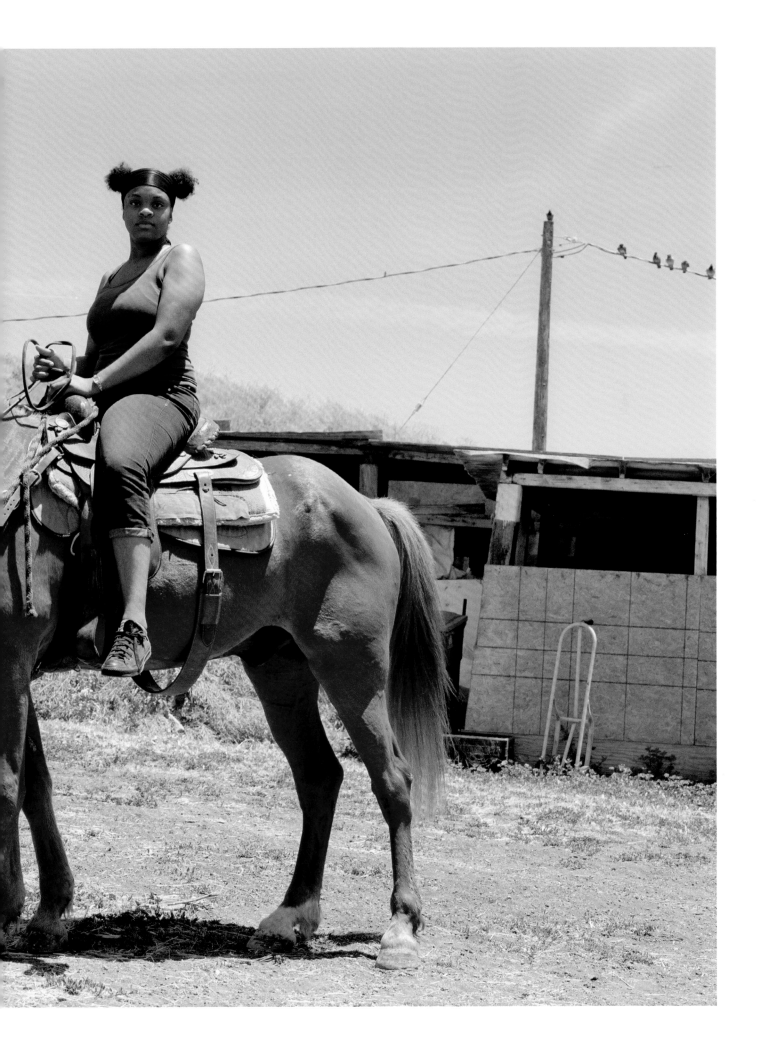

Mr. Theus is the most decorated of all the cowboys at the BPIR. He participates annually in the rodeo's Grand Entry and has been a member of the Fancy Parade Horsemen, a regional chapter of the California State Horsemen's Association, for over two decades. Mr. Theus volunteered for twenty-three years with the East Bay Regional District Mounted Police Patrol team in the Bay Area. He currently lives on a ranch in Valley Springs, California, and used to own several hair salons in Oakland called Mr. Theus. "I have a saddle by the same man that made the saddles for Roy Rogers and Gene Autry and all those guys," he says. "I bought it from somebody he had made it for, because [that person] died in '67. But that saddle I ride in is over fifty years old. It's a Ted Flowers."

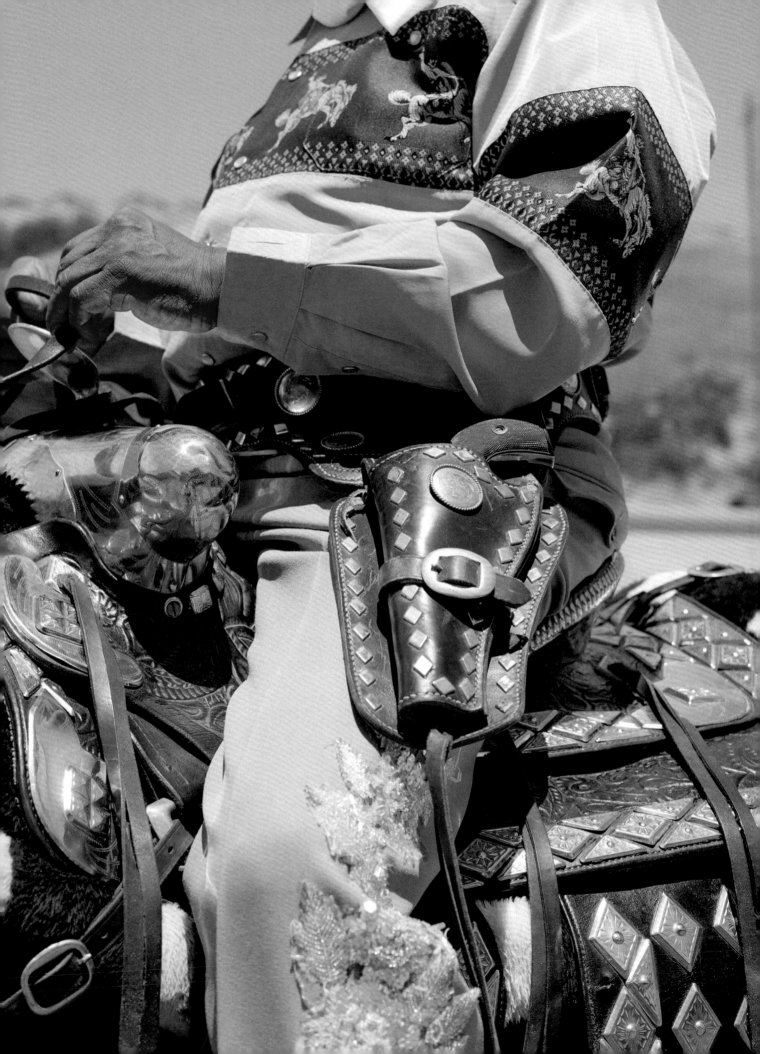

Sam Styles, shown here in 2018, started Horses with Styles so he could work with young Black riders in Oakland: "So I'm out there walking these kids, talking with these kids. And it just took me back to when I was younger and to the first time I saw a horse. It was mind-blowing for me, at the age of twenty-one, to realize that if I hadn't gone to the Oakland Black Cowboy Parade when I was younger, I would never have seen these horses. I would have never started learning how to ride, and then I would never be where I'm at now. So it was mind-blowing for me, it really was, and . . . something just came over me: that [I could give others] the same joy I was able to receive by seeing the horses and seeing people that look like me on horseback . . . give that back to the community, my community, the city in which I grew up, and give them a chance to be able to experience that same joy."

NO NAME RANCH
FREMONT, CALIFORNIA, 2018

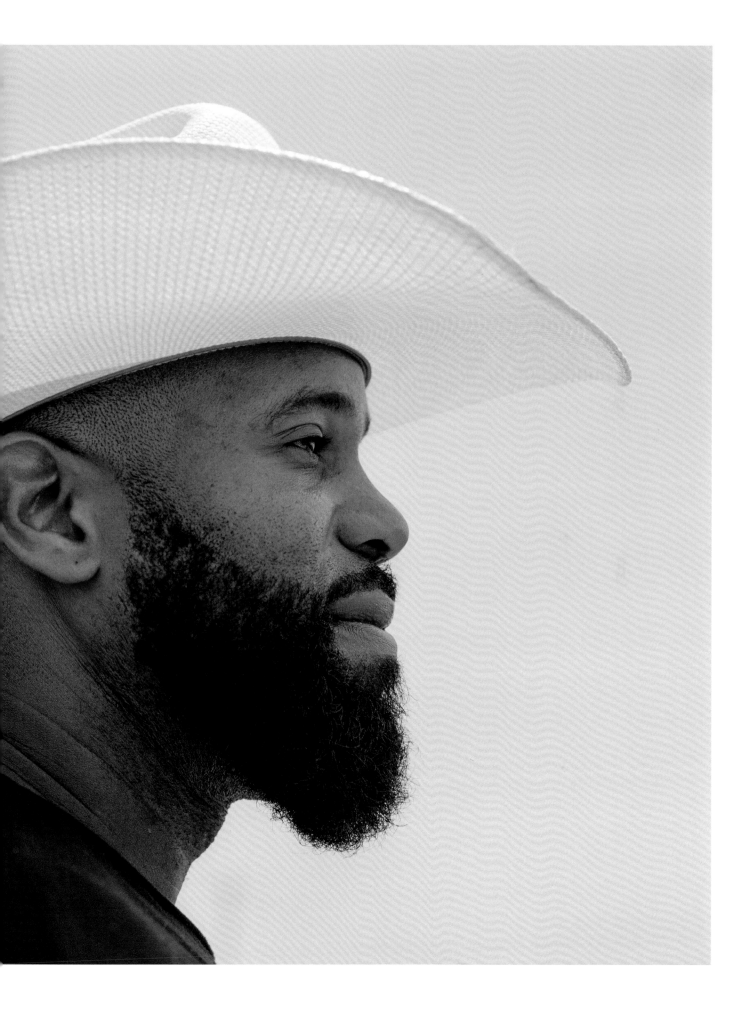

Sam Styles's first horse, Cookie, passed away in November 2020. He rode her for the first time at the BPIR when he was twenty-one. "So I had ridden Cookie at the Bill Pickett rodeo and ended up turning around and buying her a couple months later," he remembers. "Once I got Cookie . . . I was having fun helping the Oakland Black Cowboys. I would always show up to their events and walk kids on the horses. I wanted to show out, so I would dance and go sideways down the whole street, all type of stuff on Cookie."

NO NAME RANCH
FREMONT, CALIFORNIA, 2018

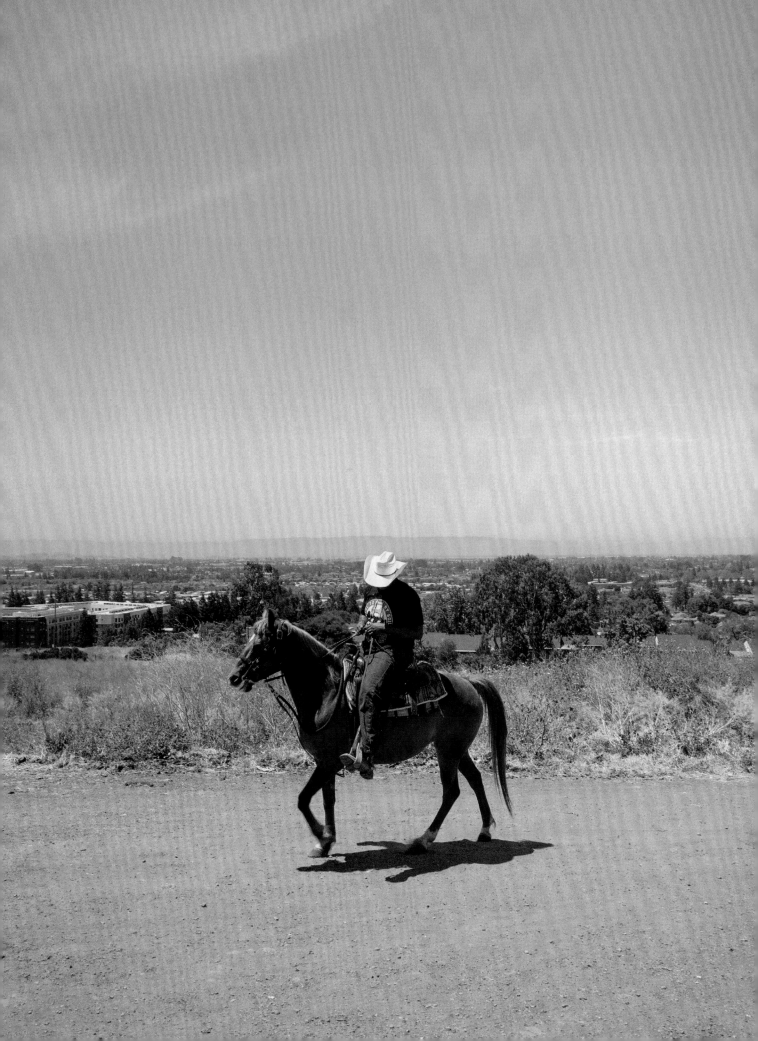

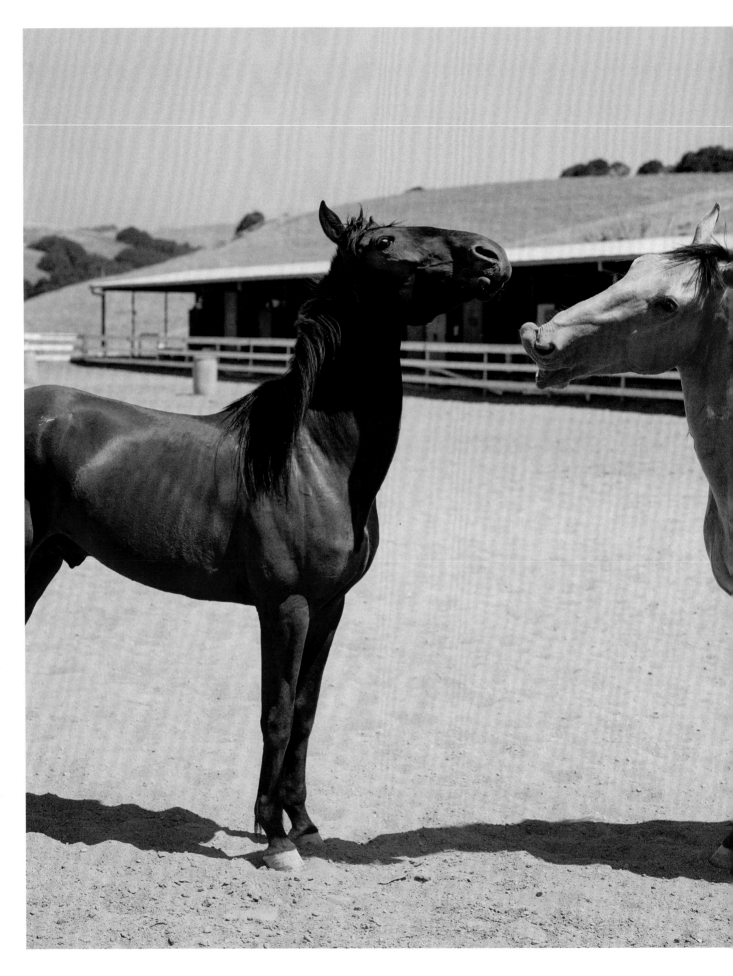

Prince Damons's speed-racing horses, Jesse James (aka J.J.) and Apollo, horsing around at Double O. D. Ranch.

next spread, left: Recording artist and music producer Prince Damons tends his horse Jesse James. "I know pretty much every time I get on my horse's back, I'm breaking the stereotype out on the trails," he says. "I see people and a lot of them give me the same kind of look, just like, 'Oh, look! There's a real-life Black cowboy?! I can't believe it.' Or, 'Where did you rent a horse?' I can see the questions on their face and just the curiosity. They want to ask but they don't, and then some of them do and they ask all the wrong questions, but I just kind of laugh about it."

next spread, right: Prince Damons and his horse Jesse James at the ranch.

DOUBLE O. D. RANCH
UNION CITY, CALIFORNIA, 2018

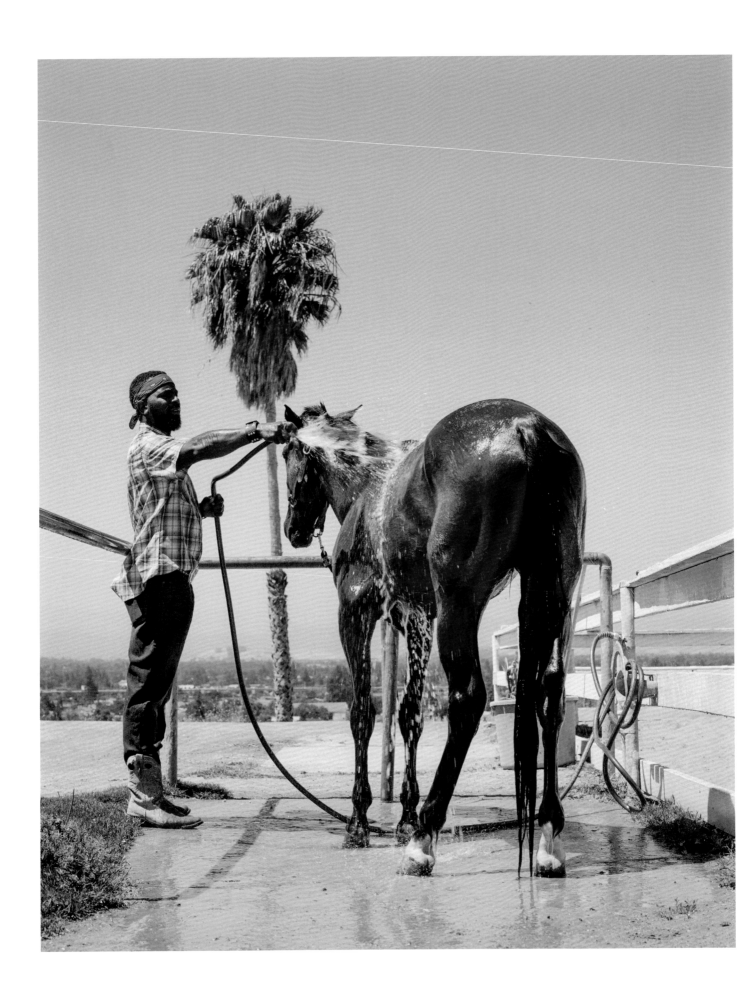

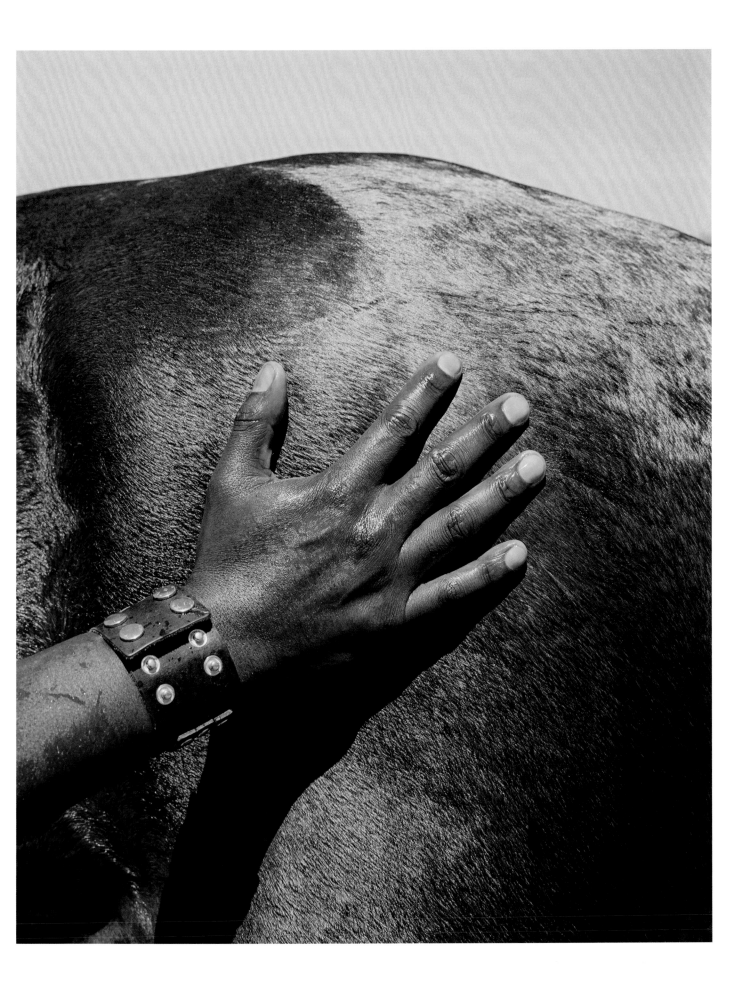

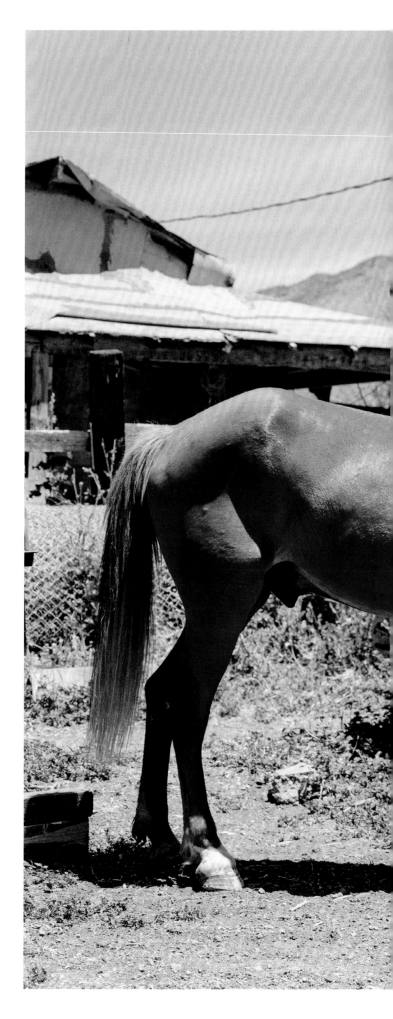

Cowgirl Iyauna Austin gets ready to ride her horse, Diamond, in the Fremont hills. Her grandparents taught her how to ride at the age of two, and she's been riding ever since. When asked about the connection between horse and rider, she explains: "Basically, if you are high-spirited, your horse will be high-spirited. If you are calm and collected, your horse will most likely be calm and collected. A horse is like a really big dog that you can't take home necessarily."

NO NAME RANCH
FREMONT, CALIFORNIA, 2018

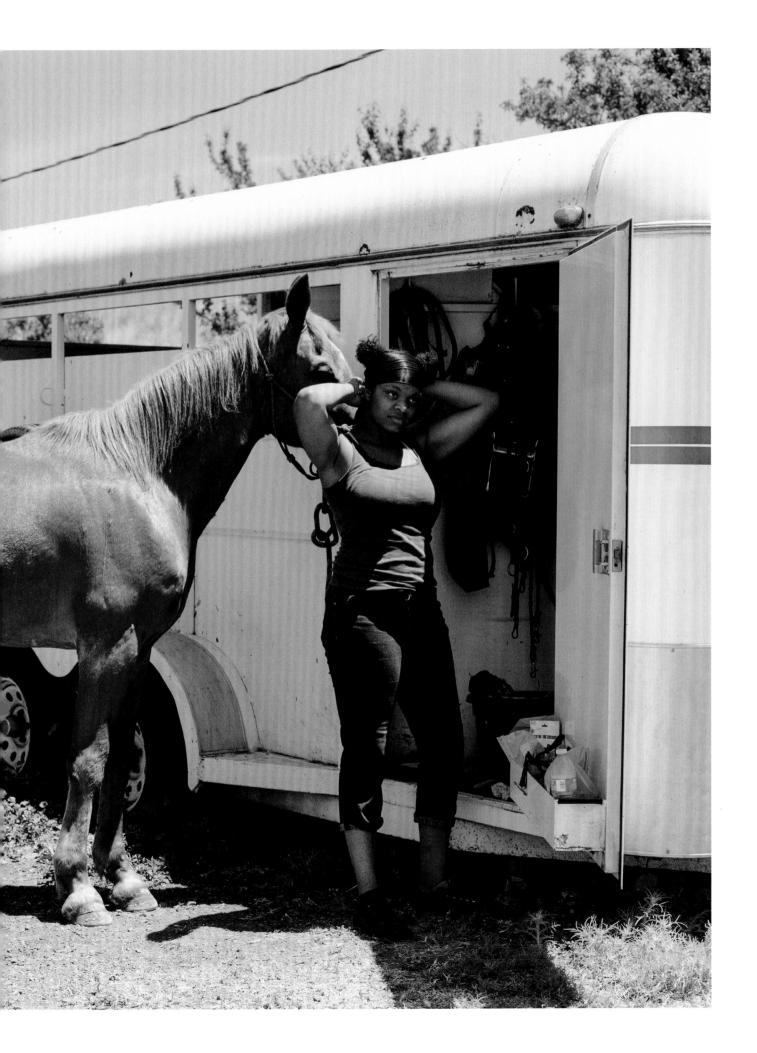

Cowboy Jordan Miller was photographed at the Loyalty Riderz campout in Lodi. The campouts are a great way to bring the cowboy community together. The riders celebrate and encourage their shared passion for horse riding, particularly with the youth.

Jordan is training to become a competitive bull rider. "The reason why I want to become a bull rider is because it's something different from all other sports. . . . It's an adrenaline rush. . . . Three of my family members passed away, and [coping with that grief] pushed me to do it more and make it to the PBR [Professional Bull Riders] or NFR [National Finals Rodeo]. I'm riding bulls for my loved ones that passed away, and also for me because I just love riding bulls."

LODI, CALIFORNIA, MAY 2021

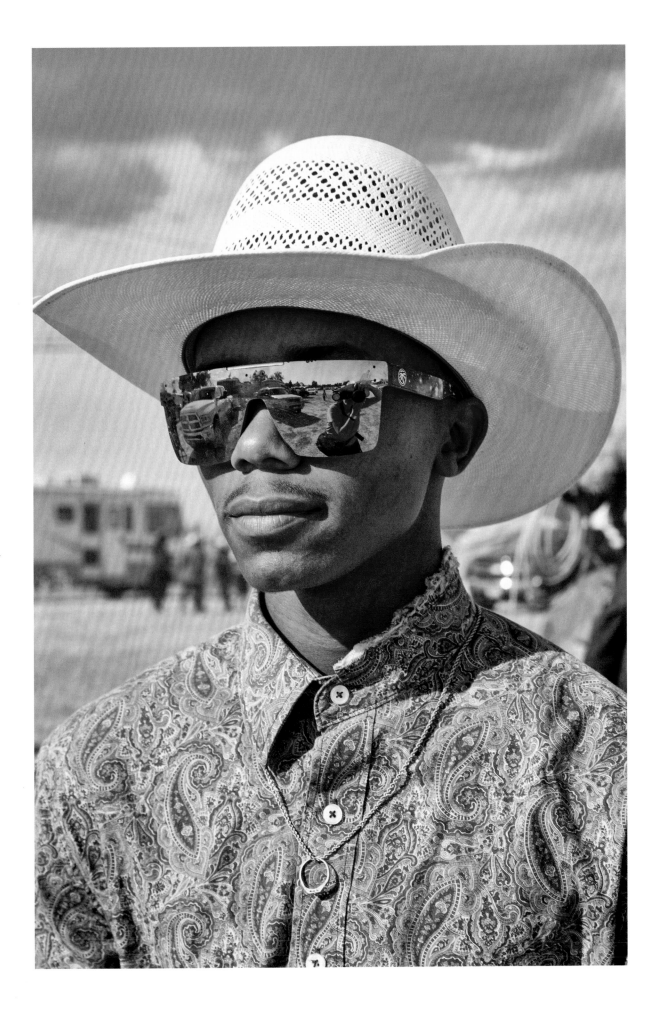

In June 2020, Brianna Noble rode her horse, Dapper Dan, in a Black Lives Matter protest in downtown Oakland. "People seemed more concerned about the destruction that would take place in our city, you know, the broken windows and stuff like that," Brianna says. "They're more angered by that than they are at the loss of life. So in an effort to change the narrative, I'm like, 'OK, well maybe I can change the headlines.' So that's why I decided to take my horse down there. . . . My entire life I've been ignored. The only time in my life I have not been ignored is when I'm sitting on a horse. It seems like nobody can ignore a Black woman on a horse."

DE FREMERY PARK
OAKLAND, CALIFORNIA, 2021

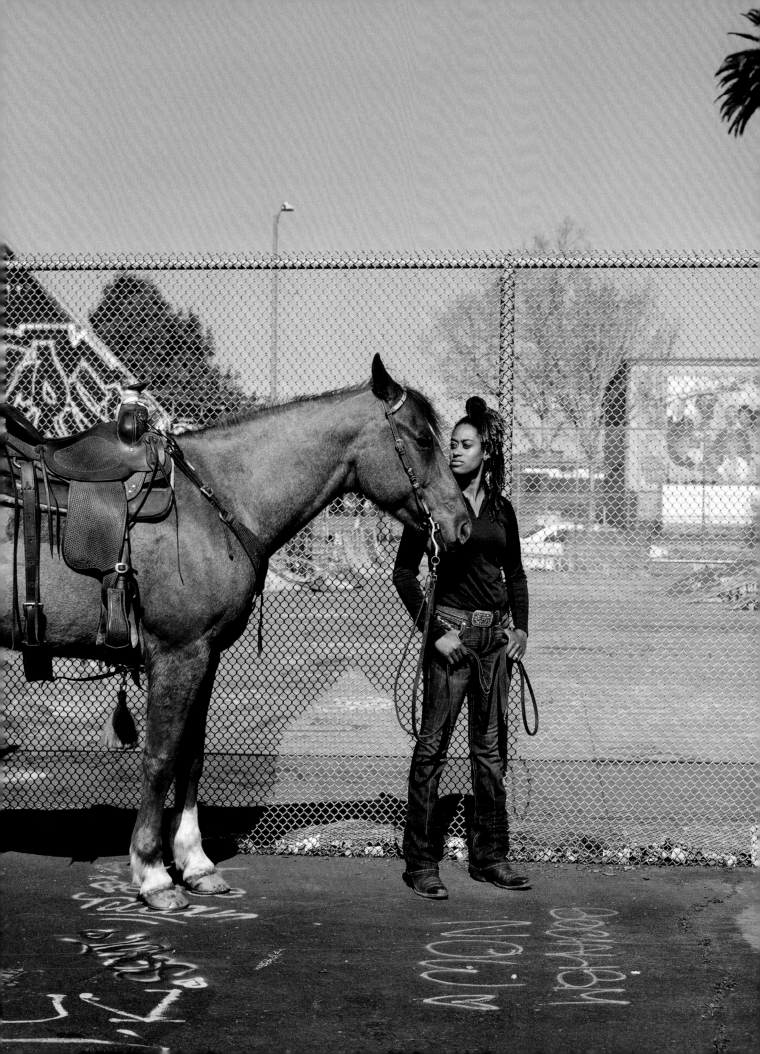

"Riding is a safe space to me, and [horses are] like my journals, without me having to write," explains Sarai Ainsworth. "I'm very internal. I don't like talking to a lot of people about my feelings and stuff. So when I'm in a hard place, that's who I go to. It's my therapy because I know that my horses can't talk back. I know that they're listening at the same time." This photo was taken at Lake Merritt in Oakland in 2020.

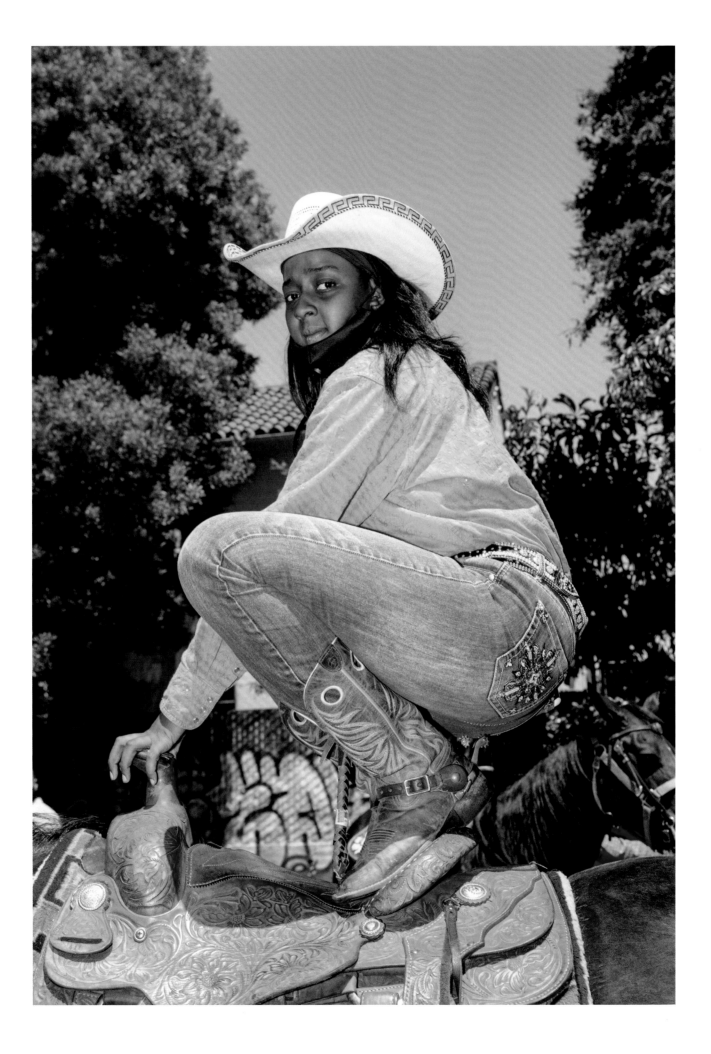

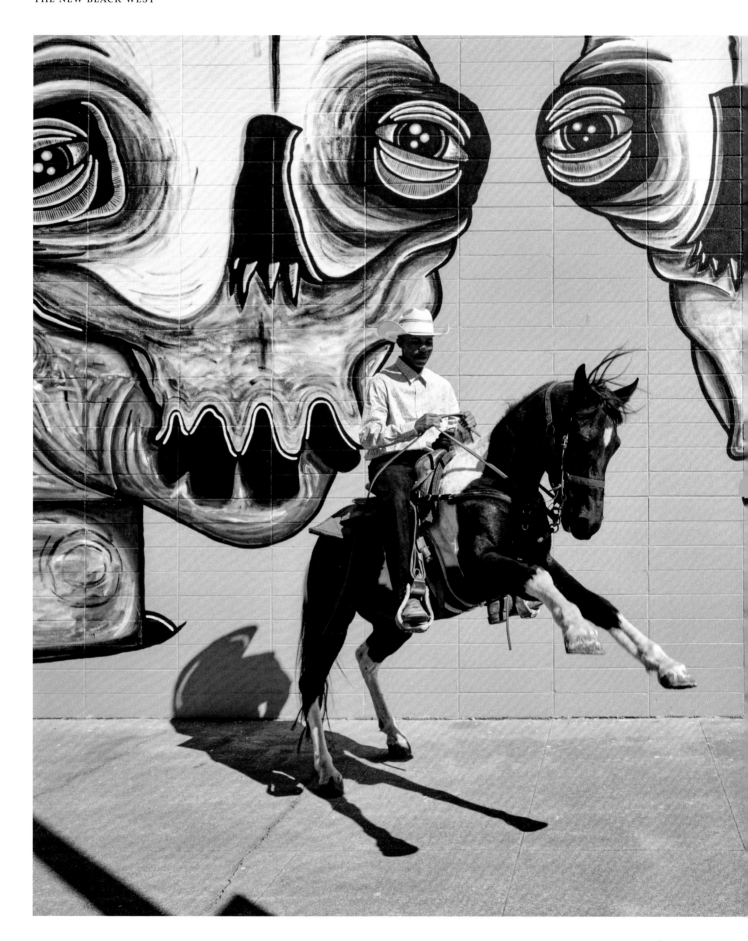

Cowboy Jordan Miller rides in the Black Cowboy Association's forty-fifth annual parade, which is held in Oakland the first weekend in October. The Black Cowboy Association is a nonprofit organization that, for the past forty years, has striven educate the community of Oakland on the historical contributions of Black cowboys. The parade and festivities held by members of the Buffalo Soldiers of Seattle, Oakland Girl Scouts, and many other local groups starts and ends at De Fremery Park after making its way through West Oakland.

**BLACK COWBOY PARADE
DE FREMERY PARK, OAKLAND, CALIFORNIA, 2019**

next spread, left: Family is central to rodeo culture. Children of former champions frequently compete, inspired by their parents' achievements. Contestants under the age of thirteen compete in the Junior Rodeo. This photo was taken in 2008, one year after ten-year-old barrel racer Vanisha McReynolds was the All-Around Champion Junior Cowgirl. Thirteen years later, Vanisha reflected on how keeping a horse impacted her life: "Rodeo makes you grow up a lot. Having a horse is a huge responsibility. It teaches you a lot of discipline and how to work in a team. You and your horse are your team. Your horse is your partner. They have to trust you to guide them and to take care of them. It's such a strong bond when making those runs. Fifteen seconds may not seem like a lot, but when you're making those tight turns at thirty-five miles per hour, you have to have the trust within them to make the right turns."

next spread, right: Veteran bull rider Leroy Patterson Jr. shows off his bull pendant necklace in 2018.

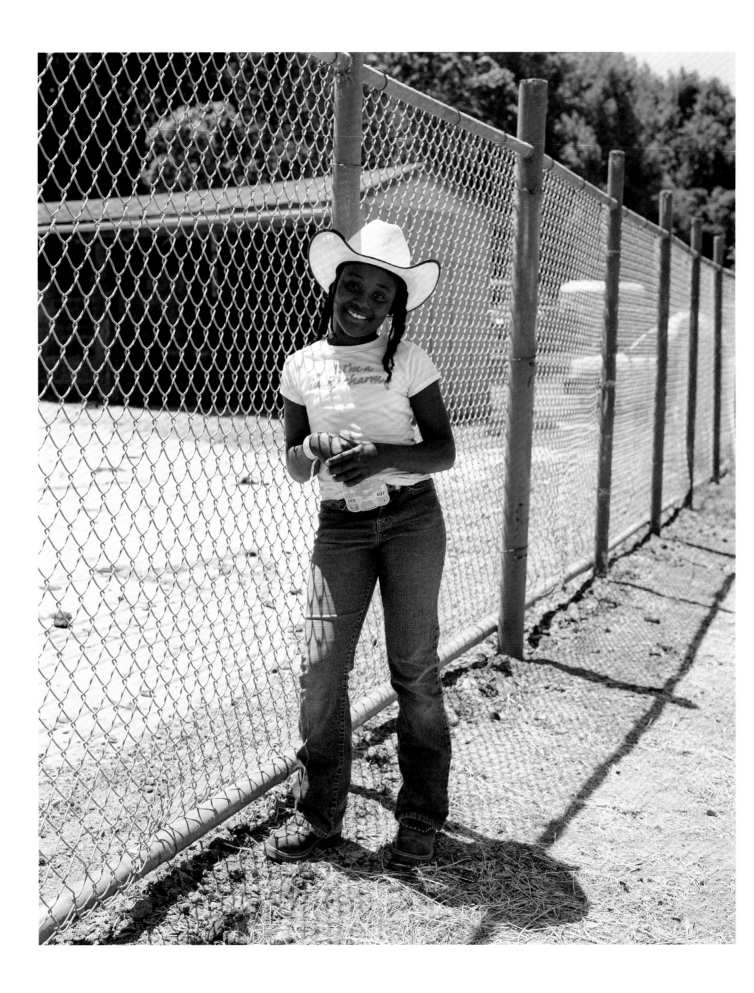

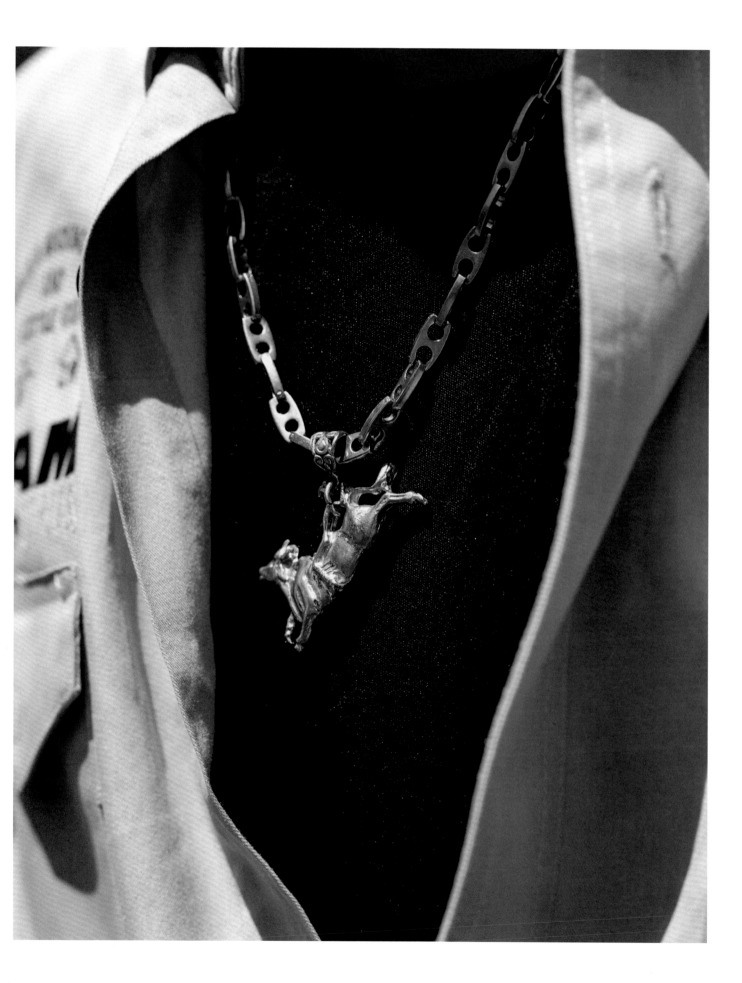

One of the most passionate riders I've met at the BPIR, and one of the first cowboys I photographed back in 2008, Joseph "Dugga" Matthews explains his connection to horses. "To me," he says, "the more you work with a horse, the more you feel comfortable with your horse, and the more you enjoy your horse and your horse enjoys you. The passion for horses has to be in your heart, to run in your blood."

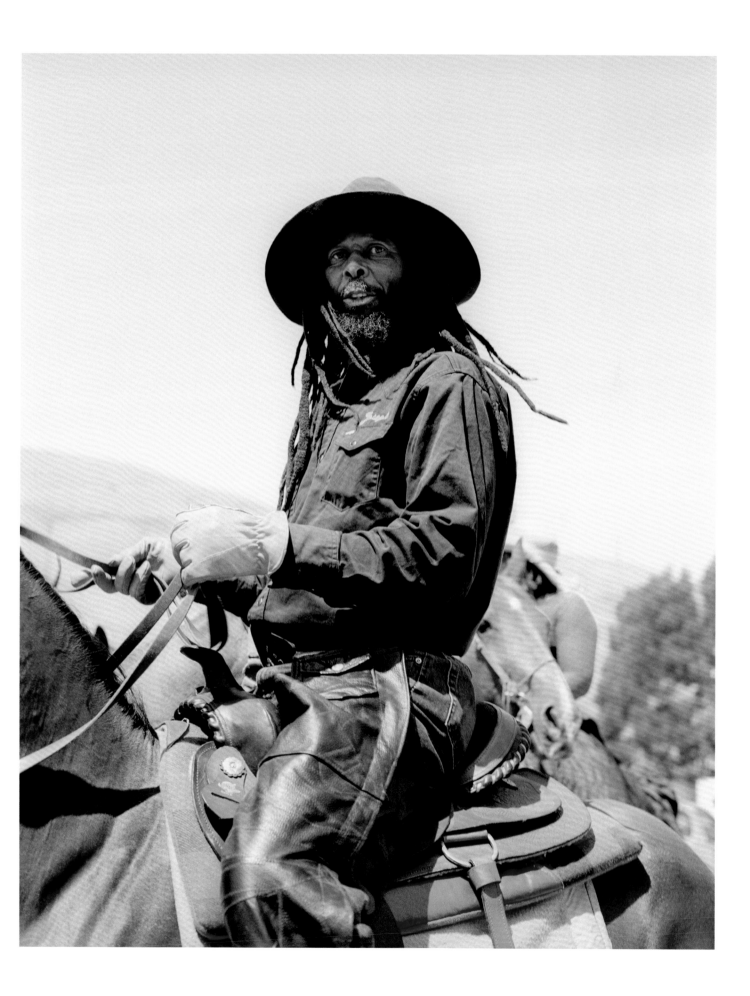

Brightly decorated chaps are left hanging between competitions. Chaps are typically used for all rough-stock events to protect the riders' legs. The name derives from the Spanish word *chaparreras*.

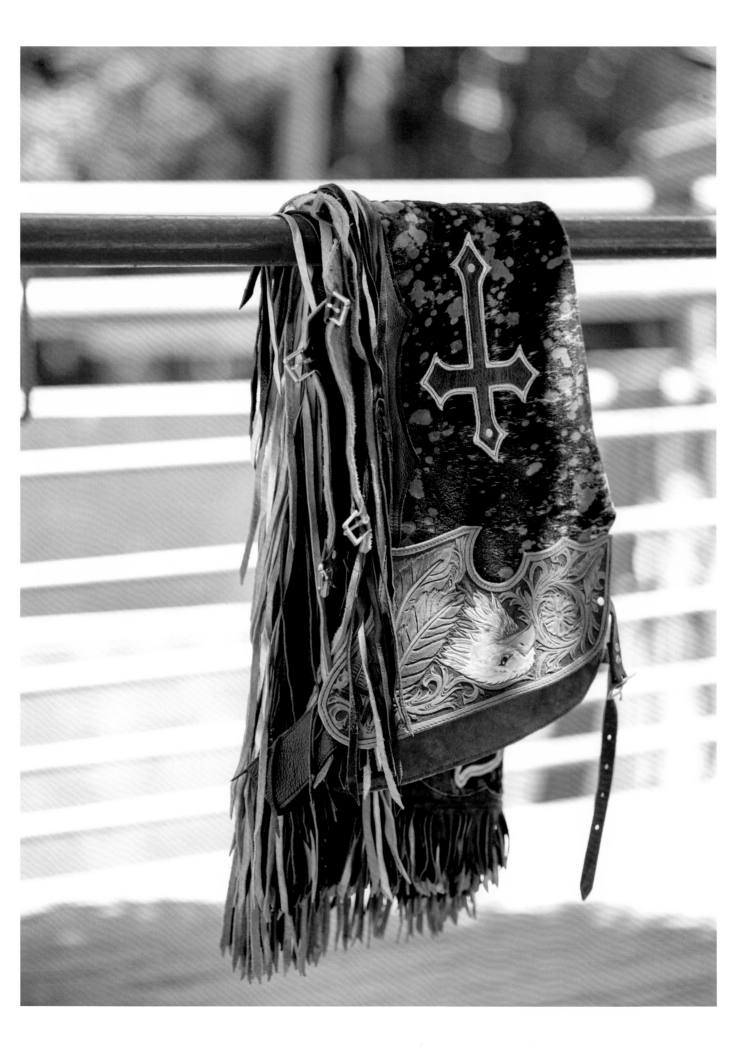

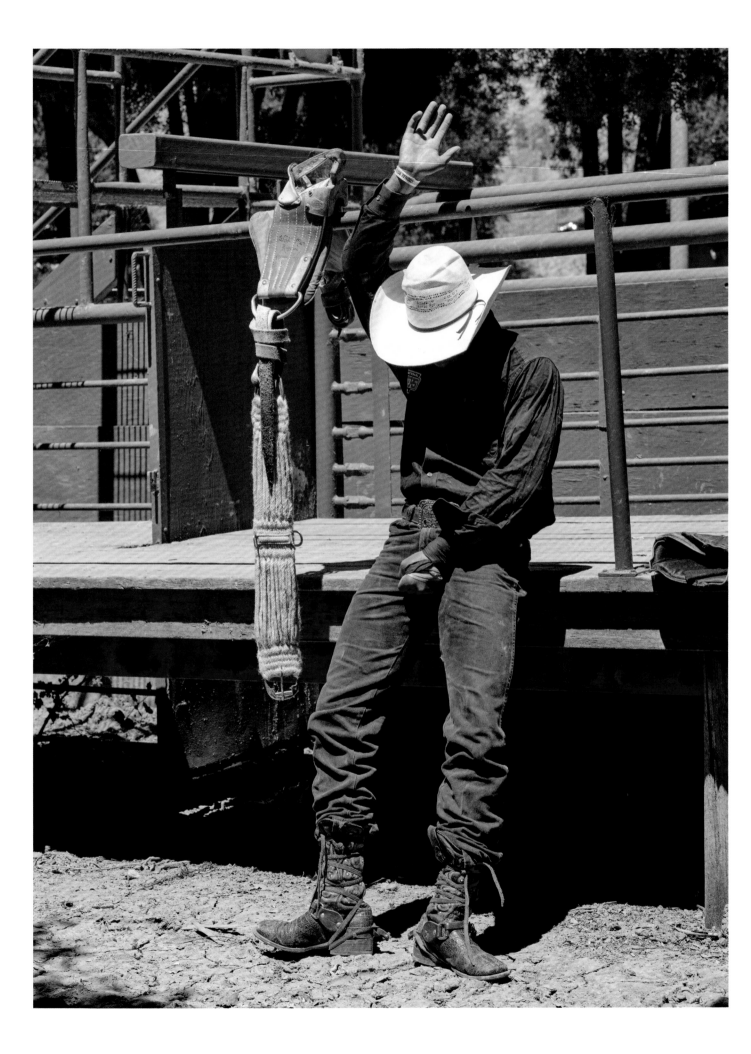

Tank Adams, a thirty-one-year-old bull rider from Oklahoma, won the All-Around Cowboy Buckle for bareback riding and bull riding at the BPIR in 2019. "I was the top money earner of the World Finals in 2019," Tank says. "With bull riding, you're gambling with your life, and you got one chance to go out there and slay a dragon. The world thinks we're crazy. For bull riders, the world pretty much disappears when you get on the back of a bull. All your problems disappear. Anything that you're going through . . . it's gone for that period of time."

Keary Hines reminisces about his hectic journey to the Oakland BPIR back in 2017, when he amazed himself by winning big. "So I flew out there on the airplane, I rode a horse I had never seen a day in my life. This was my first time flying on an airplane to a rodeo in full rodeo attire. . . . I pay the guy sixty bucks to ride his horse so he wouldn't say no. I paid him the sixty bucks, I got on this horse. I didn't know what to expect. I ended up being, like, 9.1 seconds that Saturday. I didn't know I was gonna officially win because the rodeo wasn't over until Sunday. So it was the suspense of watching the rest of the guys go for the remaining performance, and finding out that I did indeed win when on a horse that I had never been on before. And it was great. That was amazing."

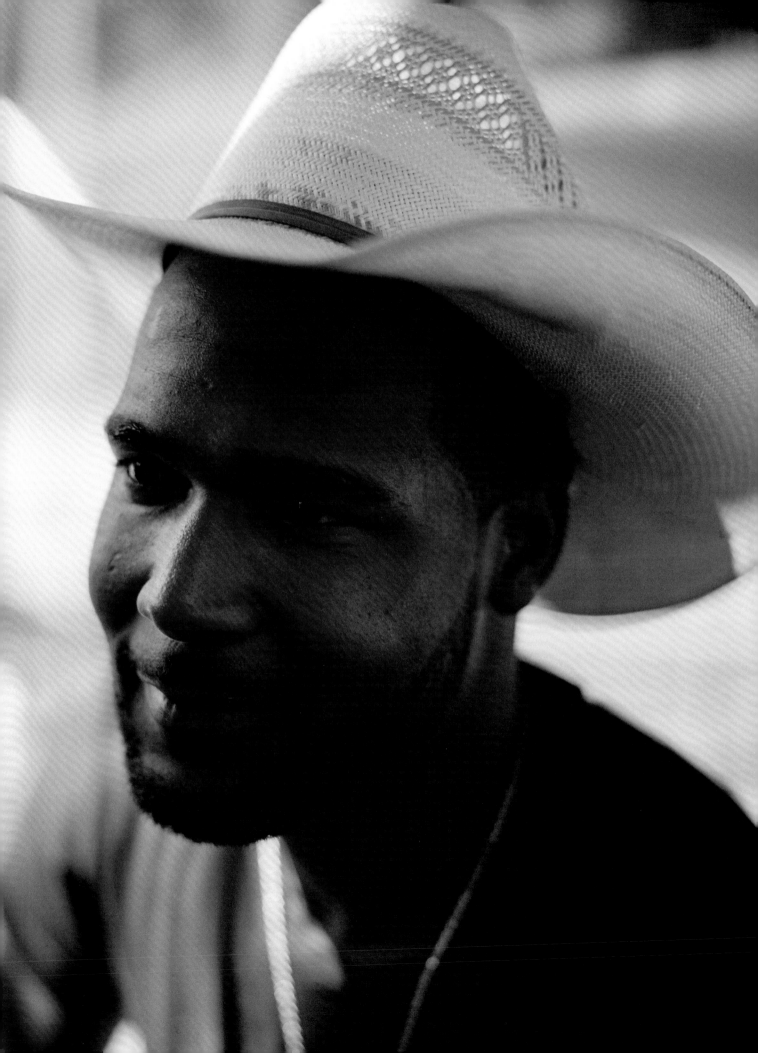

Most families who travel to Oakland spend the weekend camping out at Rowell
Ranch Rodeo Park and catching up with the rest of the cowboy community in the area.

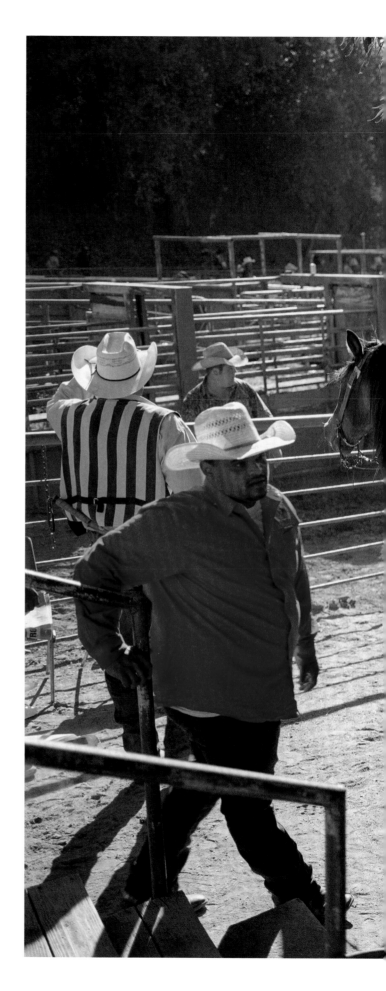

Ronald Jennings III, age twelve in this photo, was visiting the Bay Area in 2019 to attend the BPIR with his family from Texas. "I had to take care of all the steers and bulls at the rodeo and on my parents' ranch," he says. "Having horses is a big responsibility. We have to do a lot of work to keep the ranch in shape."

next spread, left: Ifafunke Oladigbolu, owner of Lola's African Apparel shop, with model Hawa Zabel in pink, here in 2018, had a booth at the rodeo for a couple of years selling traditional African clothing made in Nigeria. "I wanted to be able to help Nigeria because that's where I was born," she explains. "I came to the United States when I was eight. Lola's is a social enterprise. We only hire local independent seamstresses and tailors in Nigeria. What's really cool about selling at the rodeo is that there have been a couple of people since then that have come back to my shop, and they'll be having, like, rodeos where they want to wear African clothes, or they'll be photographed or showcasing their horses, and they just think the images of the African clothes look so good on horses. So that's been really cool getting to know people that way."

next spread, right: James Taylor traveled from Tulsa, Oklahoma, to compete at the Oakland BPIR in 2019. The Bill Pickett rodeo is held every year in Oakland on the second weekend of July. July is considered "Cowboy Christmas" in the rodeo world. Cowboys have the potential to earn thousands of dollars by traveling to different rodeos throughout the country during this month. "You can rodeo every day on Cowboy Christmas," says veteran competitor Tank Adams. "The world standings change dramatically day to day."

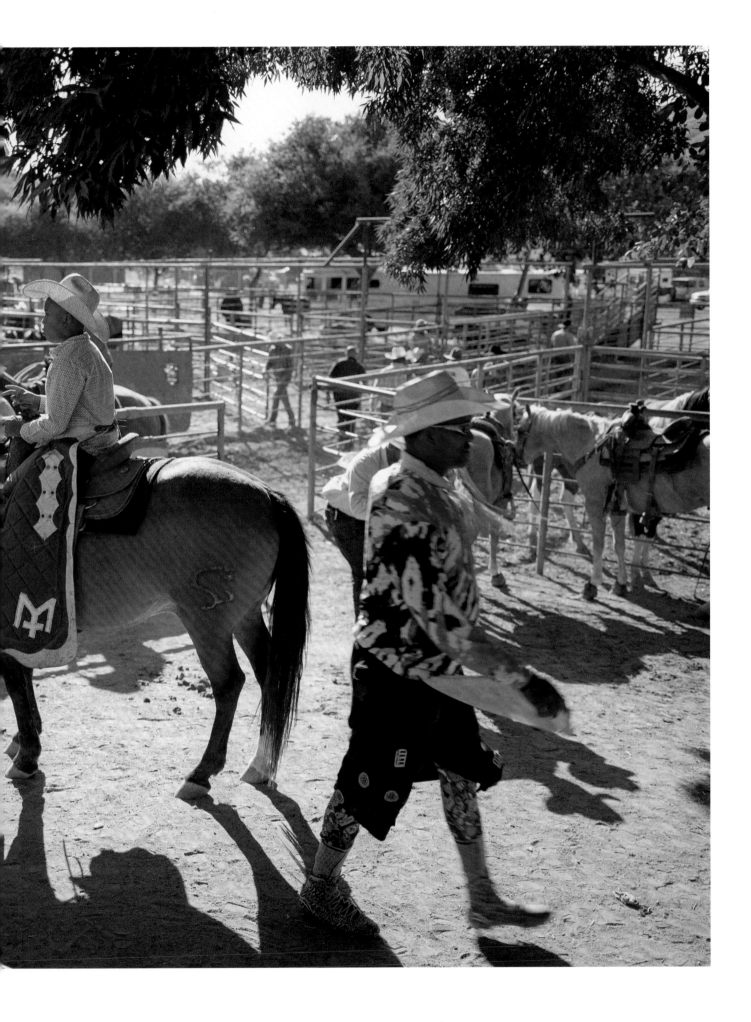

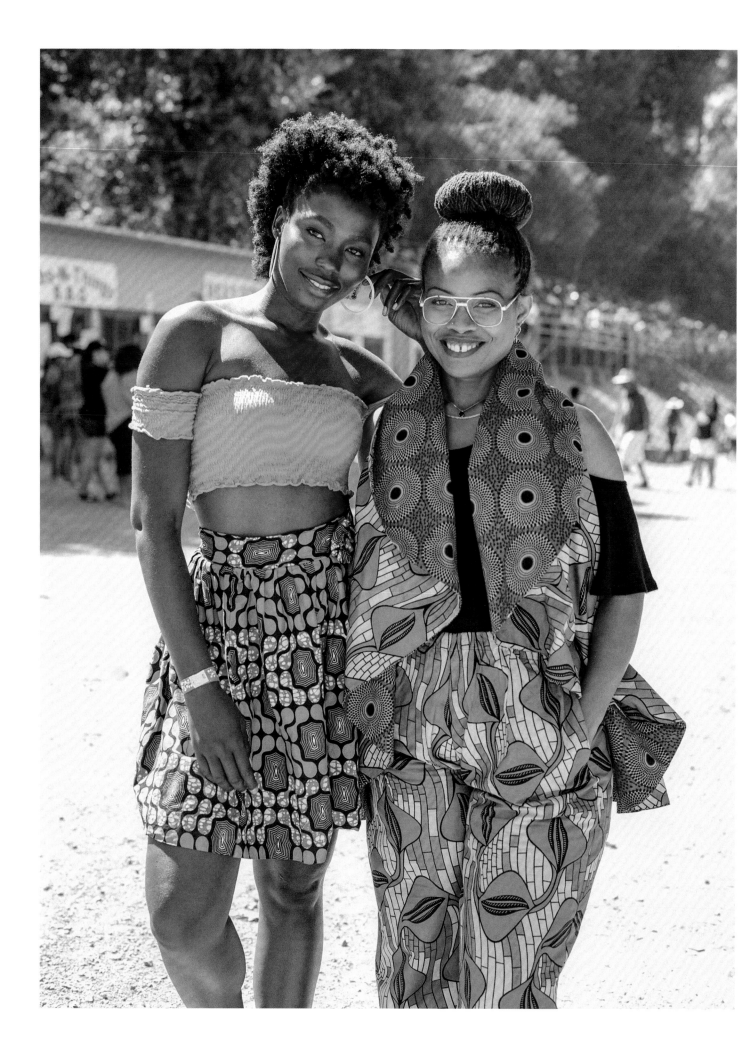

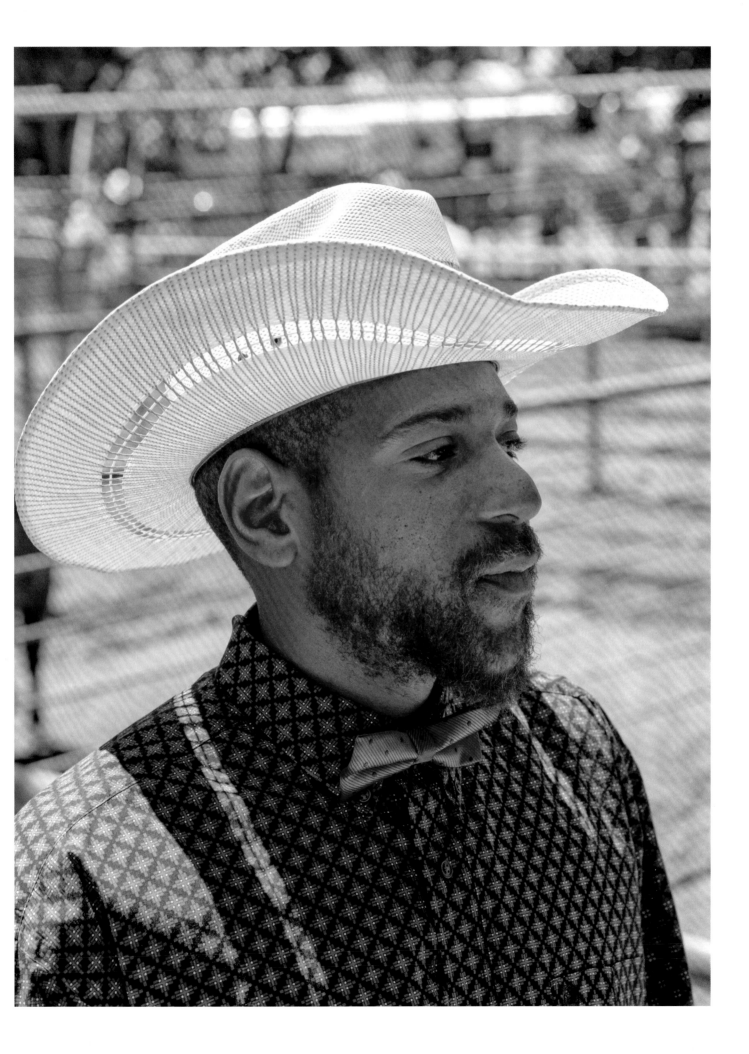

Iyauna Austin wears a custom-made skirt to the BPIR's 35th Anniversary Rodeo in Oakland in 2019. "My grandmother, Juanita Brown, and I wore the African print skirt at the Black Cowboy Parade," Iyauna explains. "Some people requested we wear it again at the Bill Pickett Invitational Rodeo, and we did. It's an exciting experience. People get to see you on your horse. They get to see the hard work you put into your horse to make you look good. What you wear also helps your horse. Your horse makes you look good. And then you have to try and make your horse look good. So it's really exciting. We wait all year for the rodeo, and then it finally happens."

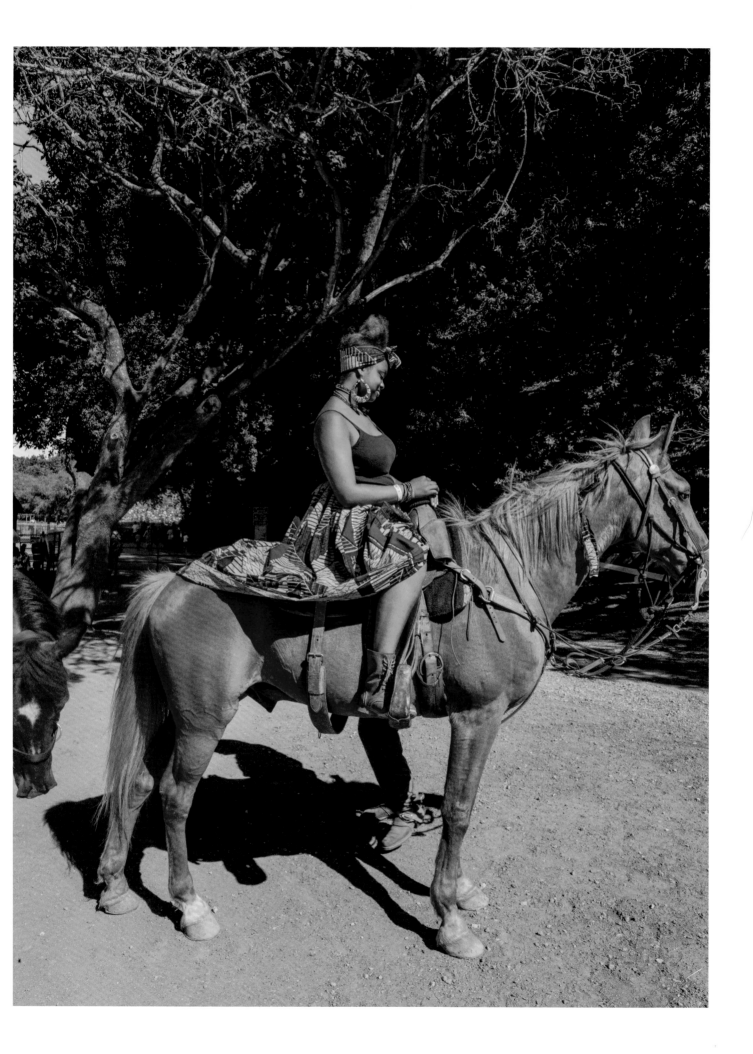

Calf roper Jermaine Walker Jr., age seven in this picture in 2019, swings his rope in the waiting area behind the arena. Jermaine is a third-generation cowboy from Hempstead, Texas. His love for rodeo was inherited from his Papa and Mimi, his grandparents Sedgwick and Stephanie Haynes, with a little help from his dad. Jermaine wants to master all the rodeo events and follow the path of rodeo champion Trevor Brazile, known as the King of the Cowboys. "Always a rope in hand," his mother, Ashley Thibideaux, confirms affectionately. "After he learned how to walk, the next thing he learned how to do was swing that rope."

next spread, left: Peruvian Paso Charlene is all dolled up for the Grand Entry in 2019. Riders typically braid a horse's mane before a parade to enhance their horse's appearance.

next spread, right: Greg "G1" Bradley Sr. is the president of the Loyalty Riderz of Northern California Coalition of Black Cowboys & Cowgirls. At the time this photo was taken in 2017, G1 rode with the Wiltown Riders, which operated as the unofficial security detail at the BPIR in Oakland for several years.

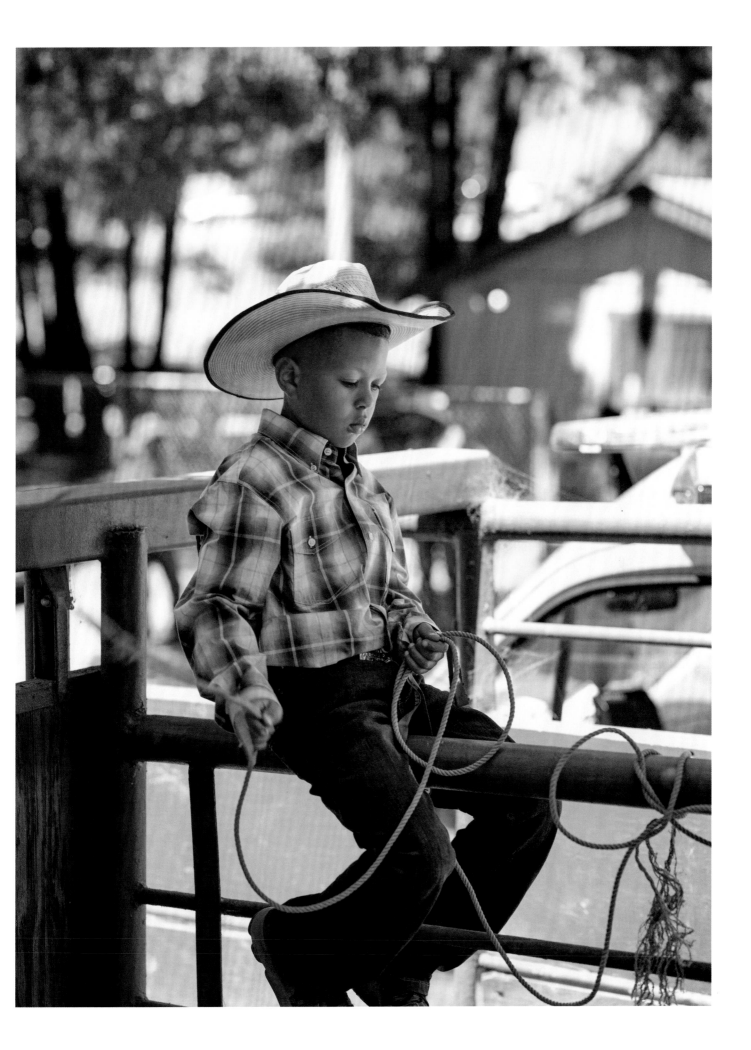

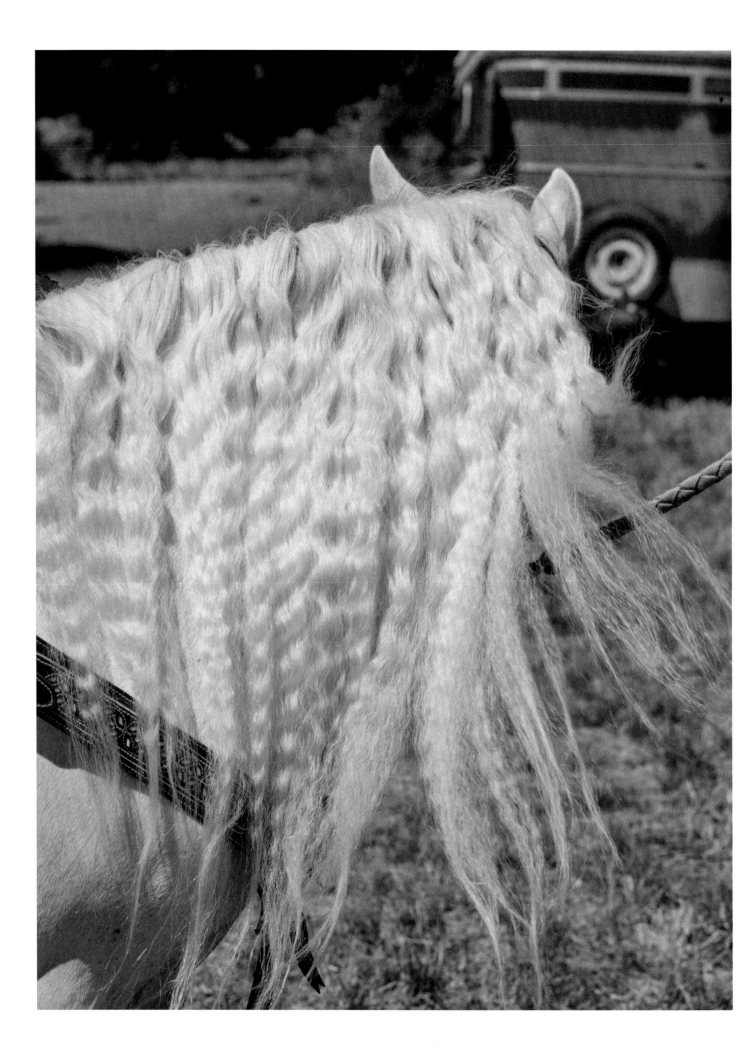

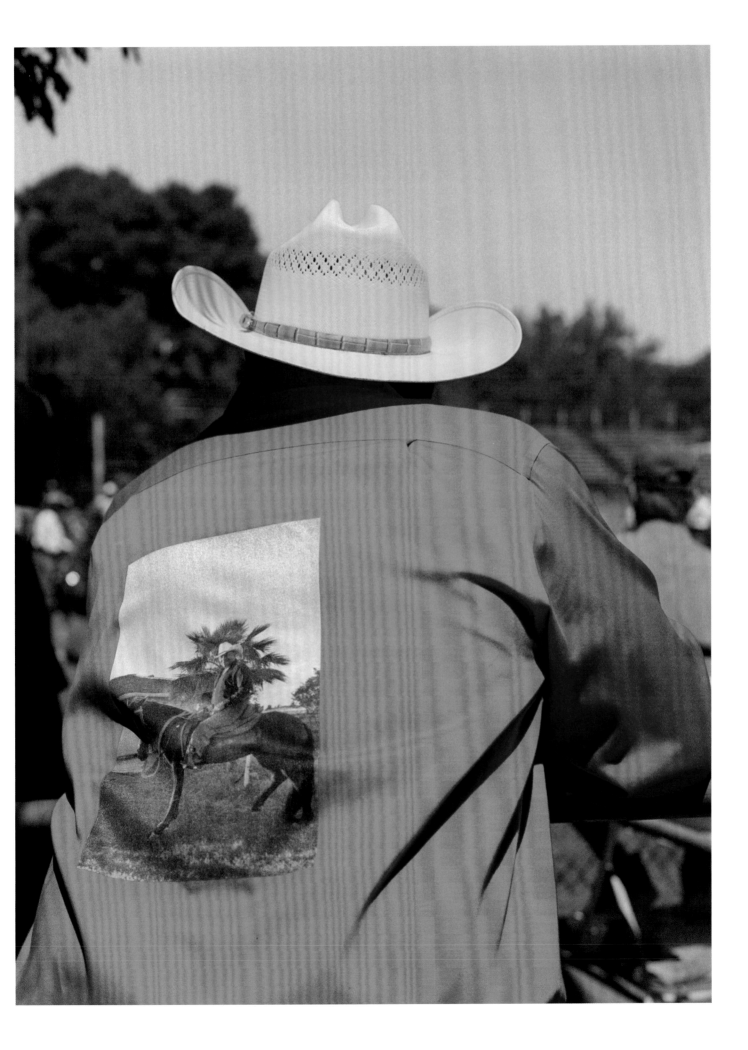

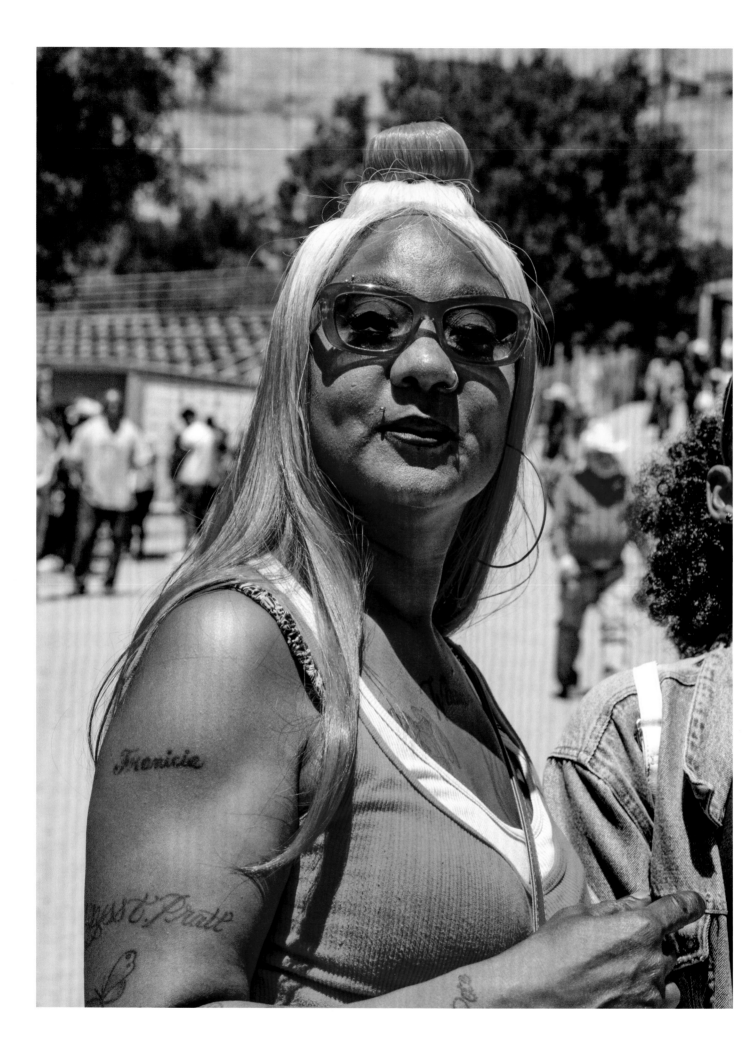

A spectator waits in line to buy food from one of the many African American vendors at the BPIR in 2019.

A young boy tries to ride a mechanical bull at the BPIR in 2009. Though fun, most mechanical bulls are nothing like riding a real bull in the arena. Bull riding has been called "the most dangerous eight seconds in sports."

next spread, left: Jewell Weaver, pictured here in 2009, is a longtime BPIR participant who started acting in Western films about twenty years ago after he was spotted wearing nineteenth-century-style clothing at the BPIR. He currently lives in the Bay Area and has a production company with his wife, Loretta, whom he met at the BPIR. Their business is called Black Saddle Productions.

next spread, right: Tabansie Burch (with hat) and Brooke Jackson grew up attending the BPIR annually and riding with all the children who attended. Here they're shown atop a horse in the rodeo parking lot in 2009. "The rodeo was a big cowboy family to me. I've met a lot of good people throughout the years that I am still connected to," Brooke says. "I am so lucky to be a part of this community."

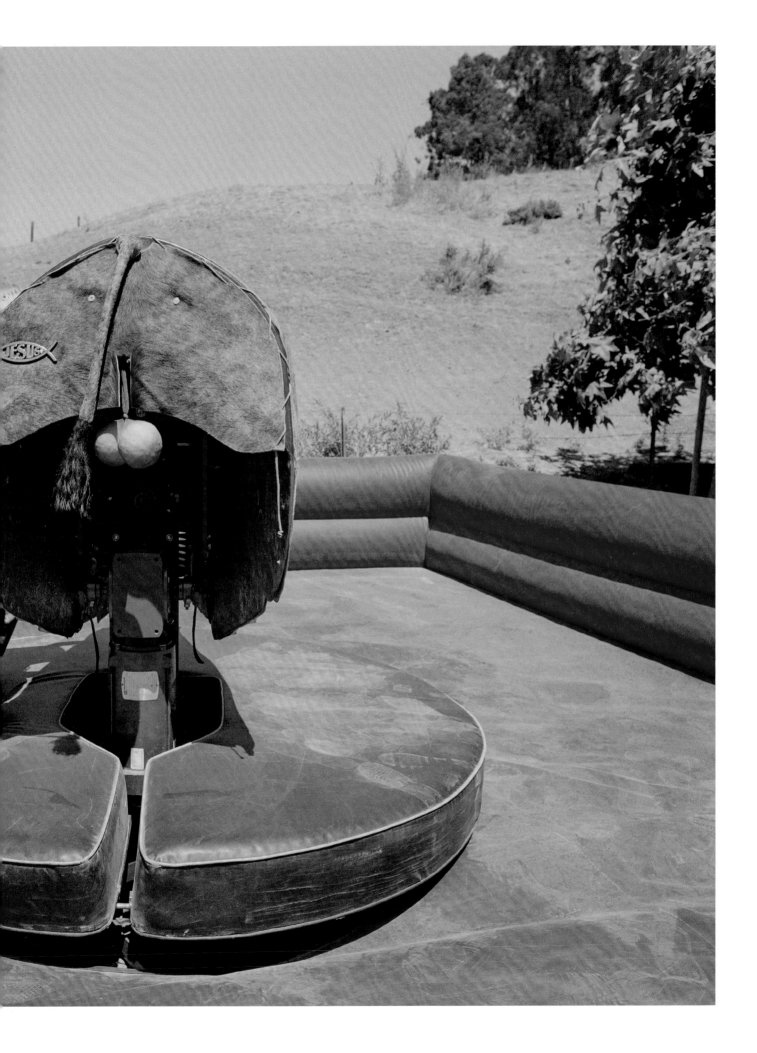

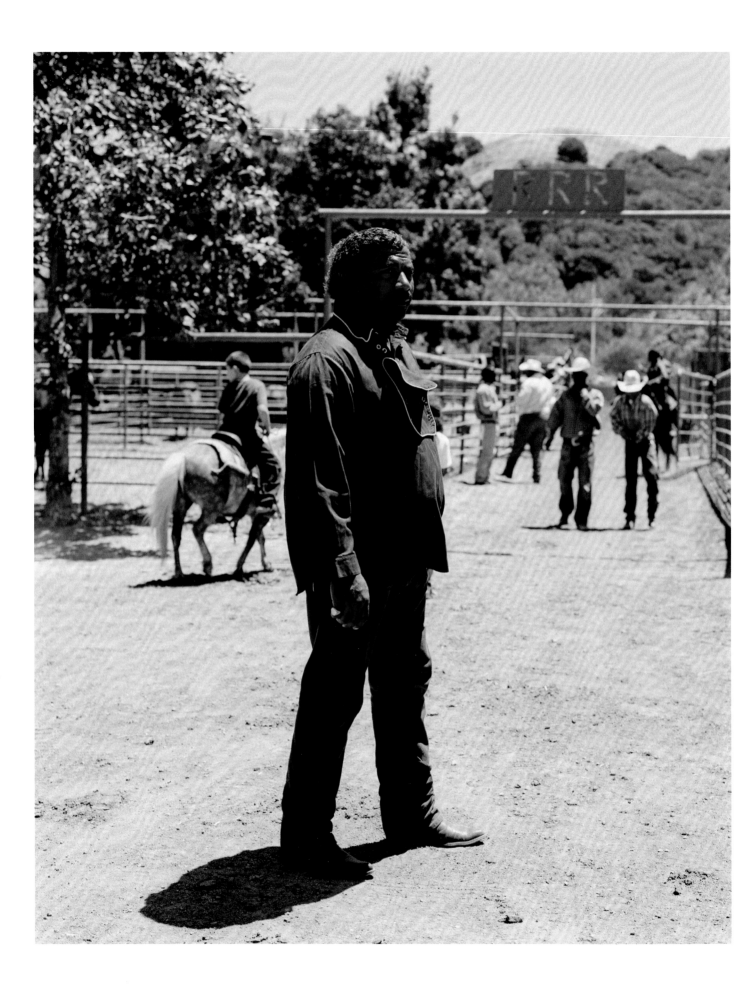

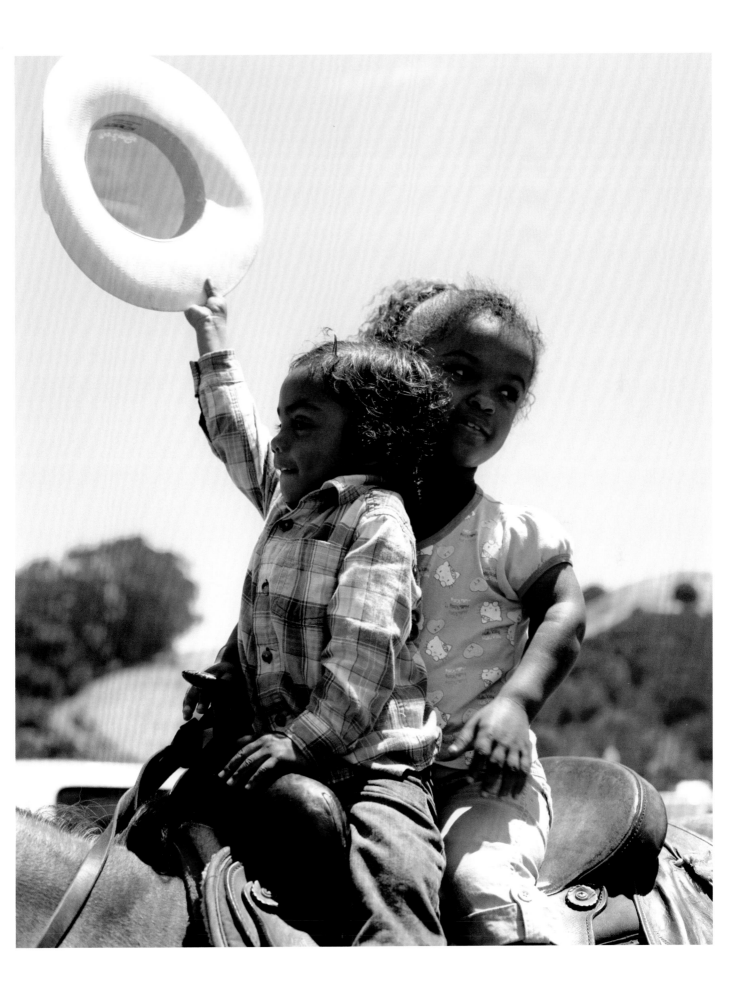

Raymond Jones Jr., known as RJ, practices his roping
skills in the parking lot of the 2017 rodeo. RJ is part of the
Brotherhood Riders Youth Club, a mentoring program for
at-risk youth in the Stockton, California, area. During the
summer months, founder Sylvester Miller takes the youth
to several rodeos across California. RJ's mother, Tamika,
says, "He's been a horseman since before birth."

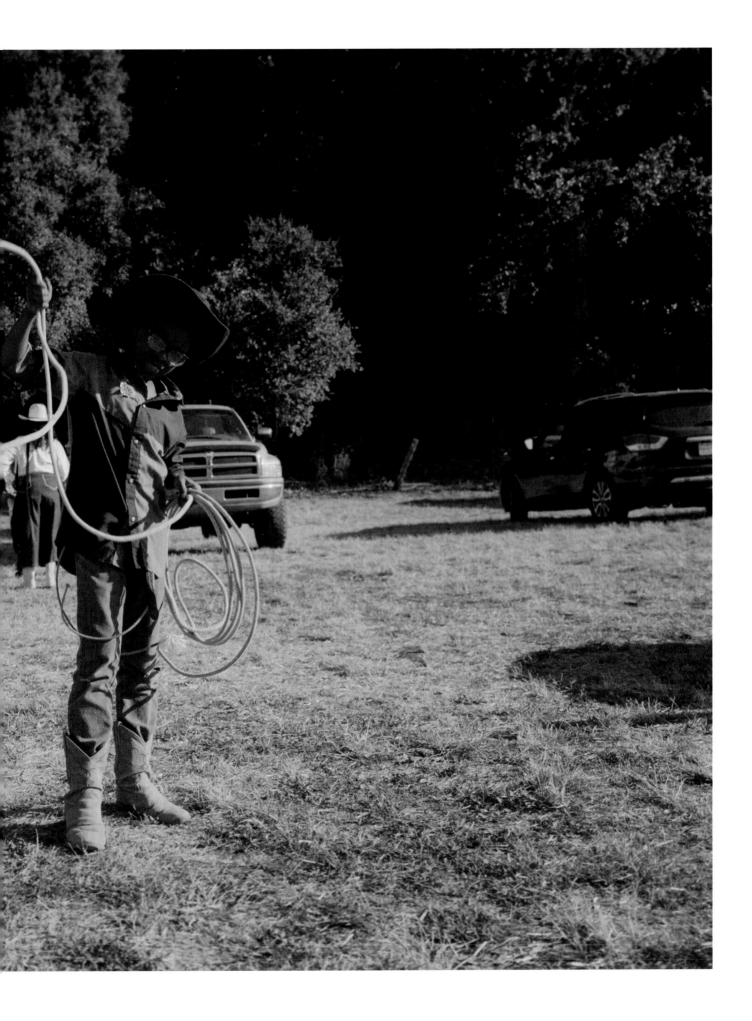

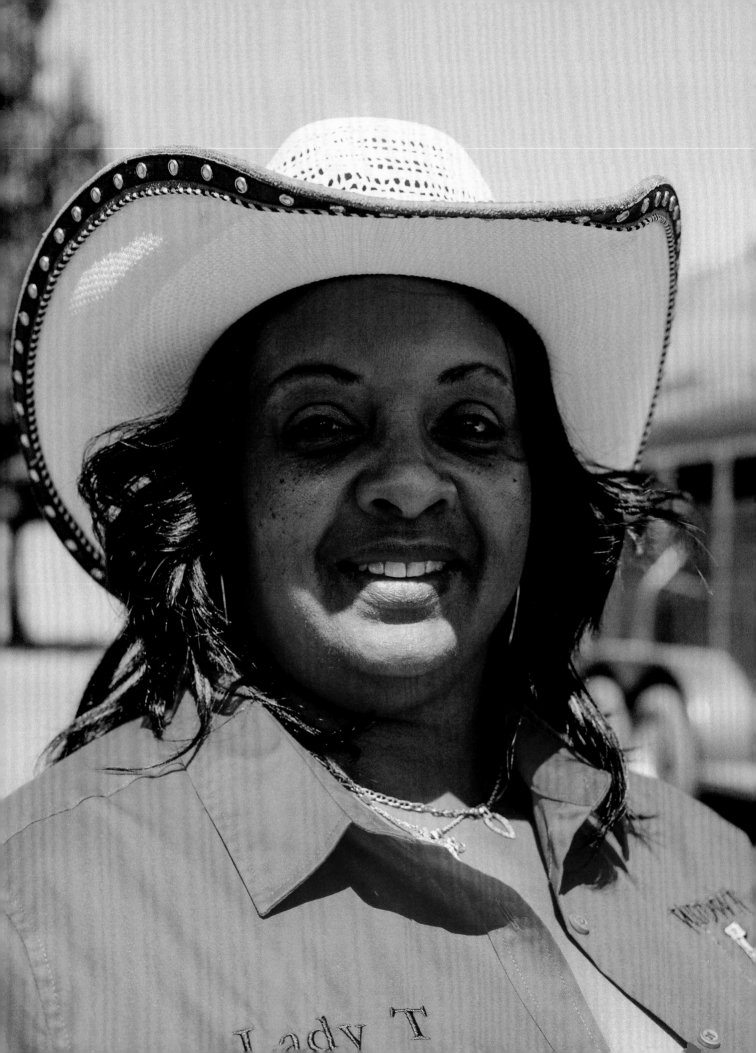

Tammy McClarty, known as Lady T, participated in the Grand Entry at the 2018 BPIR as part of the Wiltown Riders horse group. Growing up in Oakland, she never thought she'd be able to afford a horse. Contrary to her prediction, she's had a horse named Ivory in a stable in Fremont, California, for over ten years now. Her granddaughter, Sarai Ainsworth, is also starting to compete in rodeos and has been riding since she was nine years old.

Two junior rodeo champions at the 2018 BPIR, Harold Williams Jr. (in chaps) and Lindon Demery. "My whole family rodeos," Lindon explains, "and it became something I wanted to do. I started riding around age two and immediately started participating at the BPIR. My first event was in the Denver, Colorado, BPIR." Lindon participates in junior breakaway roping, steer riding, barrel racing, and tie-down. He recently won his first saddle at a rodeo in Oklahoma as a reward for being the Year-End Calf Roping Champion.

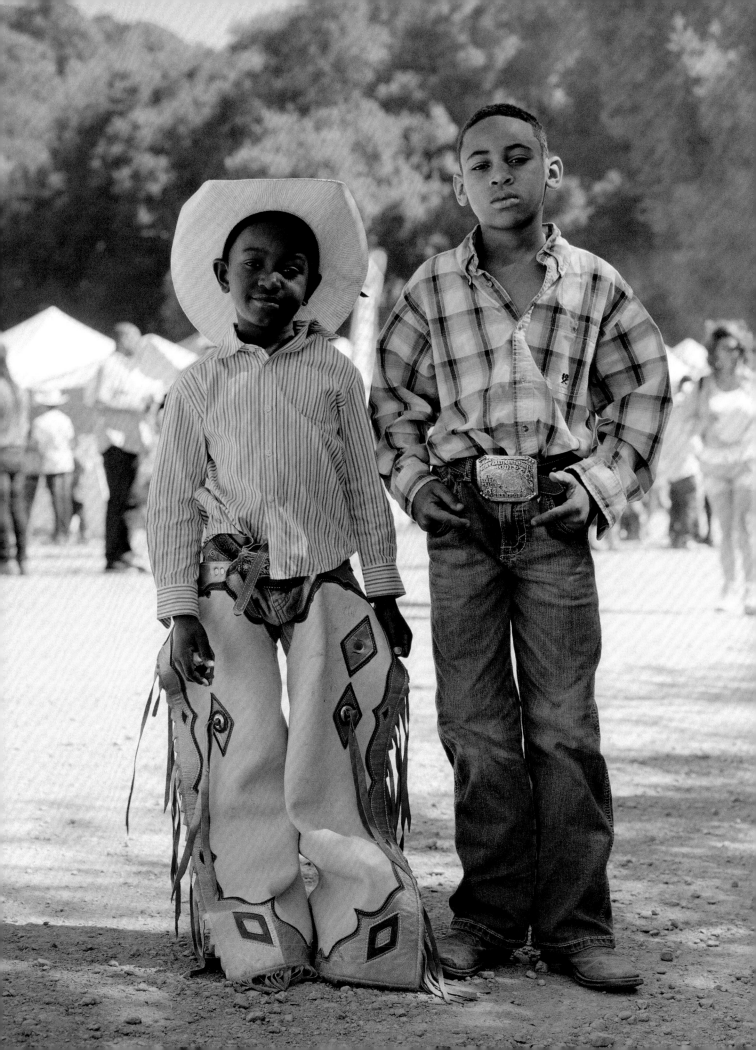

Prince Damons moved to the West Coast to pursue his passion for music. He shares how he came to love riding horses during his childhood in the South: "I guess growing up in Mississippi . . . it's a little more common for African Americans to ride horses, especially gaited horses. So I was around a lot of people riding, and I just pretty much had a love for horses ever since I can remember. Around the age of seven, I got on my first horse, and it was all downhill from there. You know, it was a wrap. I knew I wanted a horse, and I wanted to be around horses all the time. It gave me this feeling of just freedom to be able to be in touch, to really be in sync and be in touch with such a large animal and be able to go places I can't go in a car or any other vehicle. It's just a freedom about it. So I was bit by the equine bug."

DOUBLE O. D. RANCH
UNION CITY, CALIFORNIA, 2019

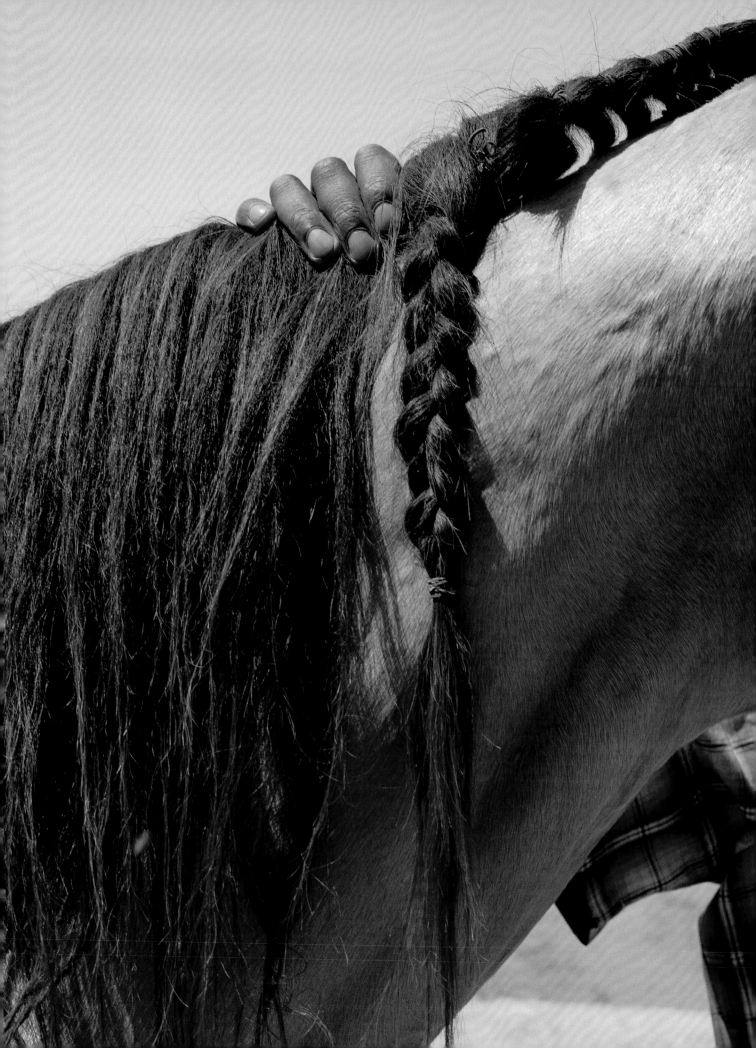

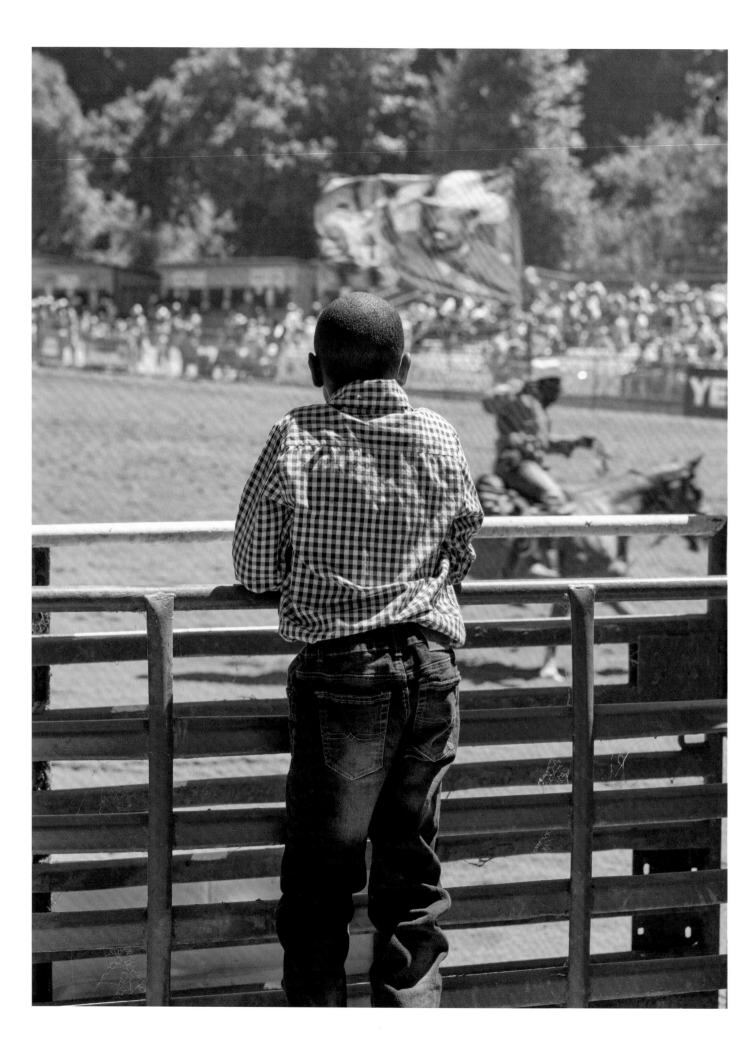

A young boy watches as a cowboy displays a flag saluting BPIR founder Lu Vason. In 2019, BPIR celebrated its thirty-fifth anniversary. The first Bill Pickett Invitational Rodeo was held in Denver, Colorado, in 1984. Lu died in 2015 at age 76. After his death, his wife, Valeria Howard-Cunningham, took charge of the BPIR. She is the only Black woman CEO and promoter of a national touring rodeo company.

Mr. Theus, here in 2009, has attended all thirty-five rodeos at Rowell Ranch Rodeo Park since the rodeo's arrival in Oakland in 1986. He recalls taking Lu Vason out to visit the Rowell Ranch rodeo grounds before Lu choose the site as the venue for the Oakland BPIR. Both he and Lu owned hair salons in Oakland and shared a passion for Black cowboy heritage. "In Concord, there weren't a lot of Black people riding," Mr. Theus says. "I had a boarding stable there, and all of my boarders practically were Caucasian. I would ride with Black people from other cities like Pittsburgh, and all that kind of stuff. But with the California State Horsemen's Association, I was the only African American in my group, Fancy Parade Horsemen, until I invited a female. And she and I were the only African Americans with the California State Horsemen's Association, Chapter Five, at that time."

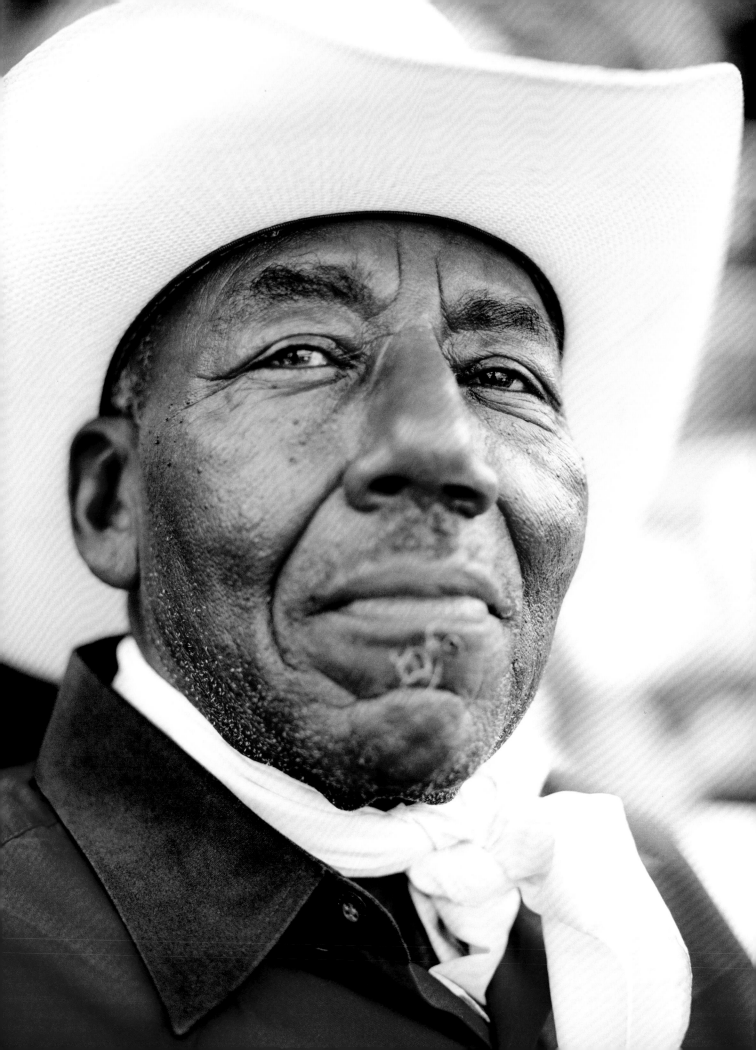

For Prince Damons, riding horses is an introspective pastime. "To get the full experience, just me and my horse being out in the middle of nowhere and it's quiet and I can hear myself think, I can hear the horse thinking and we can hear each other. So, it's kind of a . . . I don't know any other way to put it. Yeah, it's an out-of-body experience. And it's that way every time, it never gets old."

DOUBLE O. D. RANCH
UNION CITY, CALIFORNIA, 2019

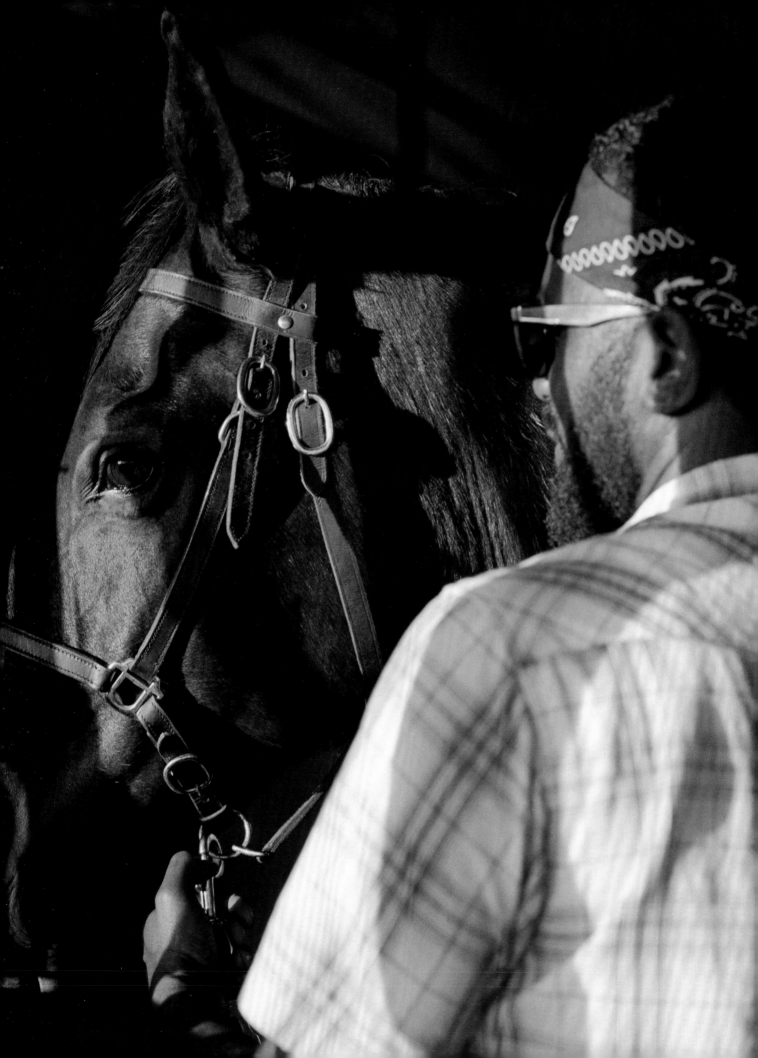

Prince Damons's horse, Jesse James, is shown here in the stable with the evening light coming through the barn gates.

DOUBLE O. D. RANCH
UNION CITY, CALIFORNIA, 2019

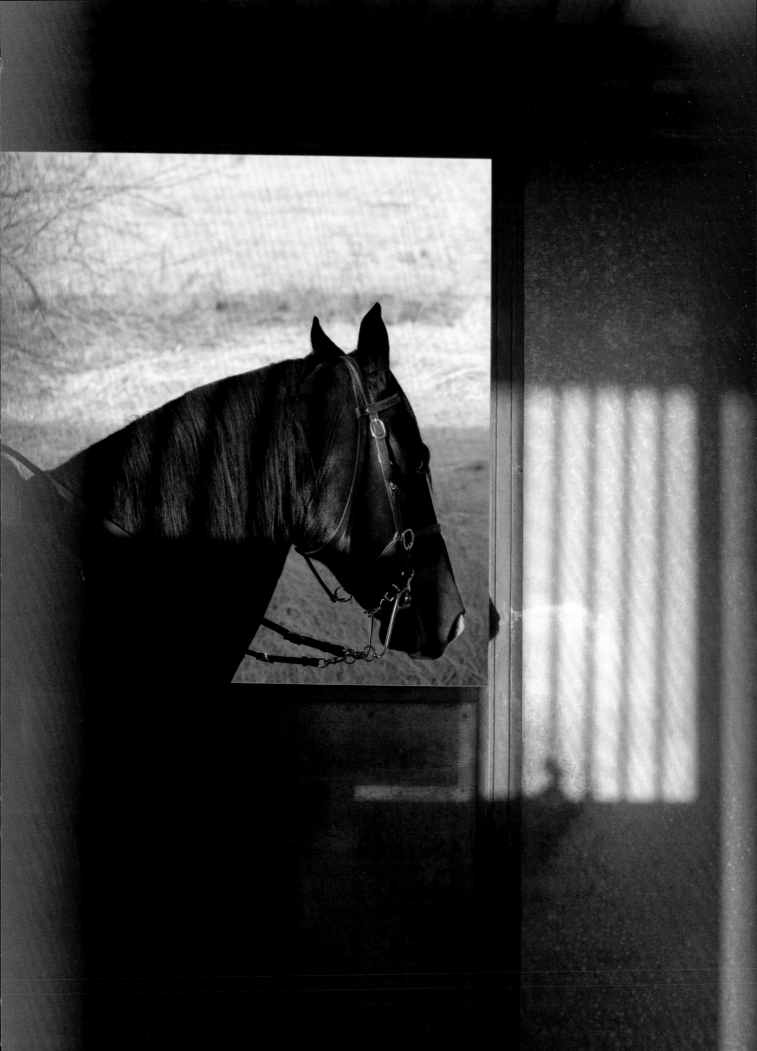

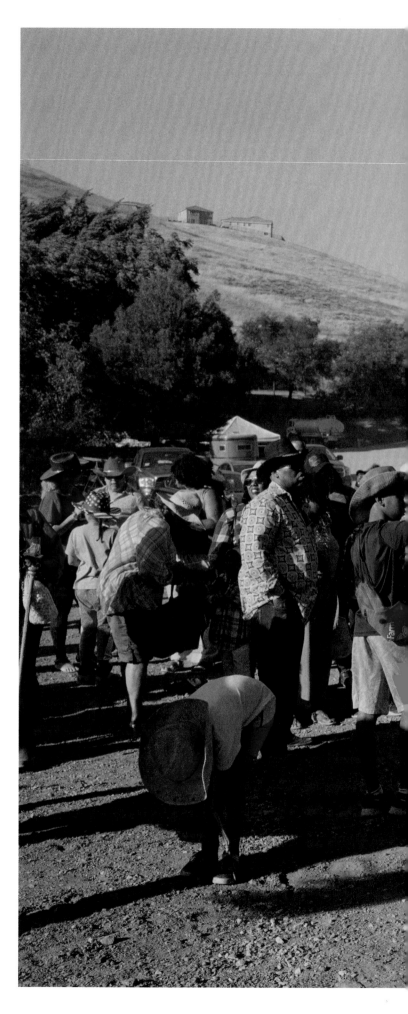

At the end of the rodeo, when the show is over, some
cowgirls, like Kysariah Brinson, stay behind to let rodeo
guests ride their horses as they walk toward their vehicles
in the parking lot. Kysariah remembers that in 2017, one
young girl said to her, "You're a Black princess and I want
to be just like you when I grow up."

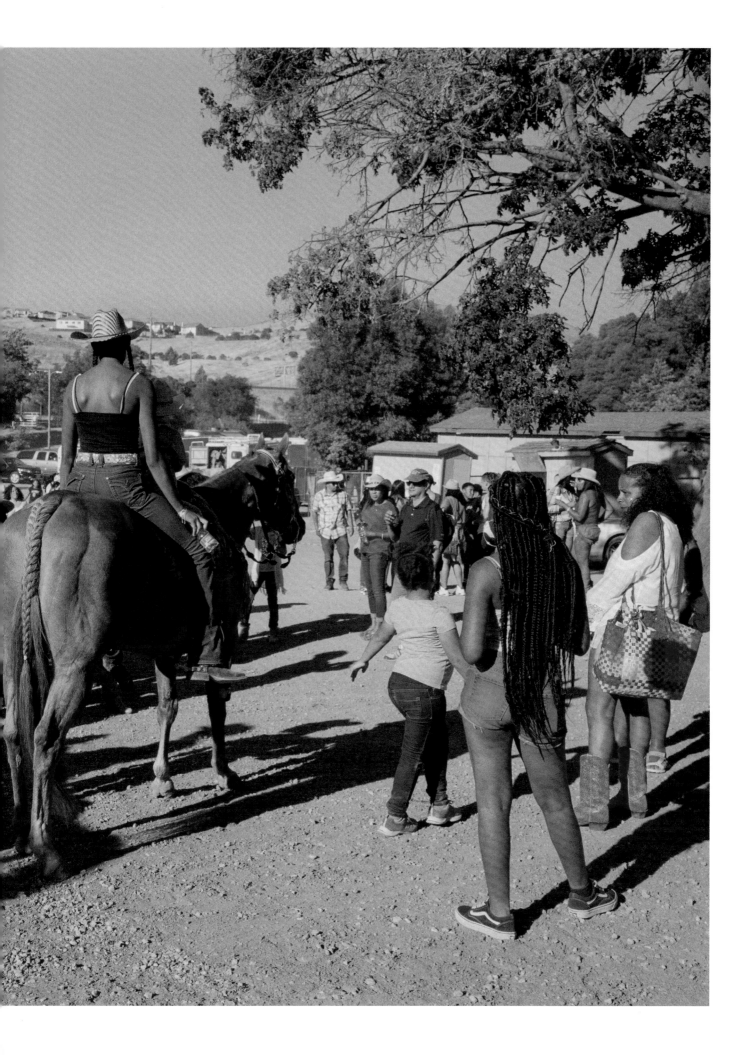

Prince Damons rides daily near his home in Fremont. "When I ride," he says, "it takes me away from everything else that I'm thinking about, any other things that are stressing me out or causing my brain to overthink. When I'm with the horses, it just kind of mellows me out. I'm just in the moment."

DOUBLE O. D. RANCH
UNION CITY, CALIFORNIA, 2019

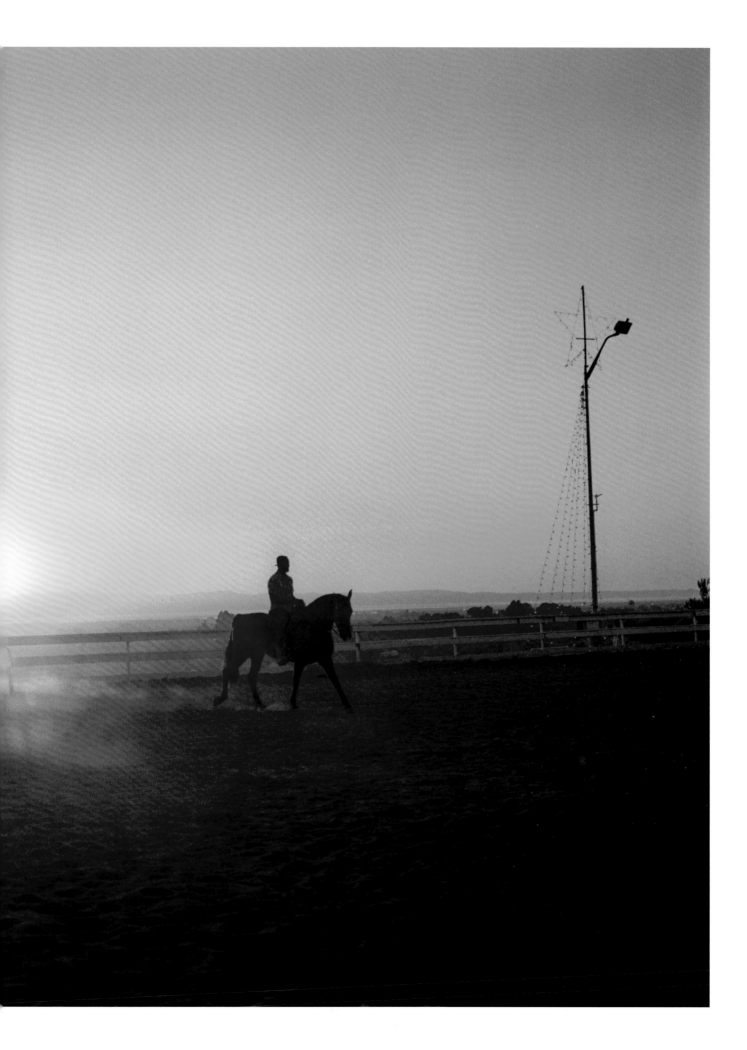

ACKNOWLEDGMENTS

It's been a real honor to work with all the cowboys and cowgirls who have shared their stories, dreams, and personal journeys with me in order to paint a more complete picture of the modern cowboy. Thank you to Iyauna Austin, Kysariah Brinson, Diedri Thomas Webb, Sam Styles, Prince Damons, Jamir Graham, Tammy McClarty, Sarai Ainsworth, Leroy Patterson Jr., Mr. Theus, and all the cowboys who I now call friends, for treating me like a sister and always, always saying yes to more pictures. Tammy, thanks to you I was able to track down folks I met way back in 2009.

Thank you to Jeff Douvel at the BPIR, who always granted me access to take photos. You are a tough (but fair) critic, and I am honored to have had your support and encouragement on this endeavor.

Zana Woods, I'll never forget the day you took me to the BPIR back in 2007 in search of authentic Southern fried catfish. I fell in love with the rodeo scene that day.

I'm eternally grateful to the entire team at Chronicle Books for giving this important body of work a space on bookshelves. Words will never be able to express my gratitude, particularly to my editor, Natalie Butterfield, for believing so fiercely in this project and for being patient and ever so kind as she read through my writing, always returning with positive feedback. To Allison Weiner for making the best design choices and selecting the most timeless fonts. Thank you to my sensitivity reader Kayla Dunigan for making sure we were considerate of everyone involved. This book is a dream come true!

Thank you to Andria Lo for being my guiding light through my first publishing process. And to all my friends who helped me make edits: Kelsey McLellan, Stephanie Ichinose, Kate Webber, and Lauren Winfield.

Above all, my heart goes out to my husband, Nicholas Tucker, who had to endure so many moods over the completion of this book, for giving me the time and space (during a pandemic, with a child at home, and with so many other dramas that I might need to write another book) to write, to skim my archives for days in order to make sure I didn't miss a single image, and to call every cowboy and cowgirl I could track down. You have always been my number one fan, and for that I am most grateful.

To anyone else I may have forgotten to thank, THANK YOU, from the bottom of my heart!